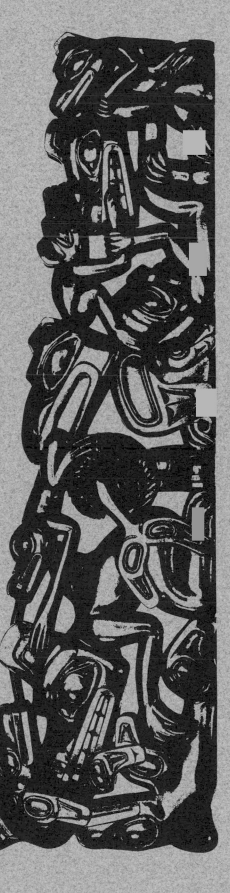

Cover: Eagle Brooch 1970
Gold and Abalone
6.5 x 4.7 cm.
Private Collection

Endpapers: Argillite panel pipe
1969 (27.5 x 7.6 x 1.5 cm.)

This book has been published with the assistance of the Canada Council.

**Canadian Cataloguing in Publication Data**

Duffek, Karen, 1956-
Bill Reid   :   Beyond the Essential Form

(Museum note, ISSN 0228-2364; no. 19) Catalogue of an exhibition held July
15—Nov. 2, 1986 at the U.B.C. Museum of Anthropology.
Bibliography: p. 57
ISBN 0-7748-0263-4

I. Reid, Bill, 1920-       -Exhibitions.   I. Reid, Bill, 1920-       II. University of
British Columbia. Museum of Anthropology.   III. Title.   IV. Series: Museum
note (University of British Columbia. Museum of Anthropology); no. 19.
NB249.R44A4 1986       730'.92'4       C86-091400-3

**Museum Note Editor: Michael M. Ames**
**Museum Note Design: W. McLennan**                    **Printed in Canada**

# Bill Reid

## Beyond the Essential Form

Karen Duffek

Foreword by Michael M. Ames

Museum Note No. 19

University of British Columbia Press
in association with
the UBC Museum of Anthropology

Vancouver

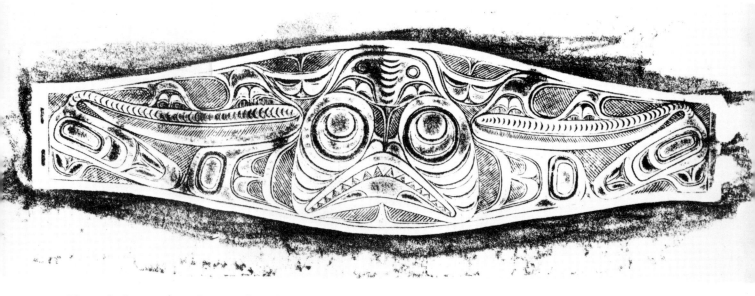

Figure 1. Impression of sterling bracelet by Charles
Edenshaw (c. 1839-1920), Dogfish (18.5 x 5.0 cm.)

# Foreword

When approaching exotic or non-Western arts, as anthropologist Clifford Geertz once said, we are confronted immediately by a haunting riddle: how can other peoples' imaginative creations be so completely their own and yet speak so eloquently to us? An answer may be found in a close examination of the works of the Haida artist Bill Reid. In the present study, Karen Duffek provides a context for this inspection that also allows us to locate Reid and his work within a broader context of Western and non-Western aesthetic traditions.

Reid played an instrumental role in the resurgence or "renaissance" of Northwest Coast Indian art, he is widely acclaimed as one of the greatest living native artists, and he ranks among Canada's most important sculptors, white or Indian. The pieces discussed by Duffek illustrate the rich Haida symbology Reid has drawn upon—the Bear Mother legend, Raven, Killerwhale, Beaver, Frog, and Wolf images, and the ingenuity and technical sophistication that are so characteristic of the Haida style—and has translated into both traditional and modern forms. His work challenges the popular notion that the essence of art lies in its quest for the new, the innovative, the avant-garde. Reid characterizes himself, in fact, as one of the more conservative practitioners of Haida art, bound to a tradition which, he says, were it not for the advent of the Europeans, might have persisted unchanged for hundreds of years.

Reid has critics, too. To some, he is only a gifted technician who has learned to copy an earlier Haida style. Others say that he is not Haida enough, capable of reproducing the form but not the spirit. He needs to participate more in Haida cultural events, they say.

Duffek suggests a way of making sense out of Reid and his critics. We have the Western notion of art as individualist expression, presumably freed from cultural inhibitions, and then there is art of and for a community, grounded in social purpose, that is collective in inspiration and conventional in form. Two artistic cultures, one the creation of a modern capitalist society that fosters competitive individualism and the other adjusted more to the social obligations of a tribal social system, are placed in juxtaposition, the one dominating the other by its size and power. Artists like Reid move between these two cultures, each searching for his or her roots, each seeking acclaim in both worlds, each achieving that acclaim in his or her separate way. *Tradition and innovation are not isolated components in art, one belonging to the past and the other to the present or future*, Duffek writes: *Both are part of a continuity, and the artist builds one upon the other as he develops his art through experimentation and*

*learning*. The artist experiments both with technique and with cultural participation. Reid, unlike some of his artist colleagues, has not played an active role in the revival of Haida potlatch celebrations and related performances, but he has contributed in other ways. He actively supports Haida land claims. In 1977-78 he produced a fifty-five-foot totem pole for his mother's village of Skidegate, the first to be erected there in a hundred years. And his most recent mission was to return the art of canoe making to the Haida—engineering the construction of a massive, fifty-foot war canoe as the Haida contribution to the 1986 world's fair on communications and transportation held in Vancouver. Each artist seeks his or her own passage home.

Karen Duffek's monograph is published as a complement to the special exhibition of Bill Reid's work at the Museum of Anthropology which opened on 15 July 1986. It may also be seen as a companion to Dr. Marjorie Halpin's exhibition and book on the "Indian" works of Jack Shadbolt, entitled **Jack Shadbolt and the Coastal Indian Image.** Halpin and Duffek both work toward a critical discourse that encompasses within one understanding Reid and Shadbolt, tribal and modern art, and that continuous dialectical tacking back and forth between particularity of origins and generality of appeal that characterizes fine art everywhere.

The exhibition and publication of Bill Reid's work was supported by the Canada Council, the Museums Assistance Programme of the National Museums of Canada, and the Cultural Services Branch and Lottery Fund of the Government of British Columbia. The Museum Note series is assisted by the Leon and Thea Koerner Foundation and the Anthropology Shop Volunteers. We thank Bill Reid, Dr. Martine Reid, Toni Cavelti, Robert Davidson, Jim M. Hart, Peter Macnair, Doris Shadbolt and David Young for their assistance and advice. We are also pleased to acknowledge the assistance of the author herself, who here provides a major contribution to how we might think about contemporary Indian art.

Michael M. Ames
Director, Museum of Anthropology

# Contents

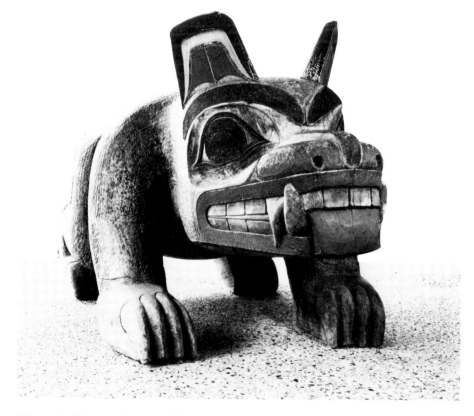

Figure 2. Bear sculpture, 1962. Rare precedents of similar sculptures were used in earlier times as memorial figures.

# Preface

Since 1951, when Bill Reid introduced himself to Audrey Hawthorn, the UBC Museum of Anthropology's first curator, Reid has had a vital and enduring relationship with this museum. The museum's development, from the small but energetic facility in the basement of the UBC Library to the Arthur Erickson-designed building that opened in 1976, has always involved native artists in a variety of projects. Many of these projects included Bill Reid as the major participant or consultant. He has been an important inspiration to young artists as well as museum staff and continues actively to encourage and support native art studies and carving projects in both urban and rural settings.

It is appropriate, then, that the Museum of Anthropology present the exhibition, **Bill Reid: Beyond the Essential Form,** opening on 15 July of this important year for Vancouver. The 1986 World Exposition, the Vancouver Centennial, and the Museum of Anthropology's tenth anniversary in its new building are all matters for celebration.

The exhibition presents a selection of Bill Reid's works that demonstrates the range of his creative expression. You are encouraged to look beyond the glitter of the gold and silver to see the detail, technique, and form manifested in each piece. In this catalogue, Karen Duffek provides us with a critical context in which to assess Reid's work, and, beyond that, addresses the broader question of the place of Haida art in the twentieth century.

This exhibition was made possible through the generous co-operation of numerous individuals and institutions. Many collectors view their Bill Reid jewellery almost as extensions of themselves, wearing it daily. To these people I am most grateful for permitting pieces to remain on show for an extended period of time. I would like to thank Bill and Martine Reid for their assistance, and Doris Shadbolt for her support and co-operation. Finally, Karen Duffek's collaboration is gratefully acknowledged: her contribution to the realization of the exhibition has been an invaluable one. We also greatly appreciate the financial support of the Canada Council which made the exhibition possible, and our special corporate sponsors who assisted with all our 1986 Centennial and Expo programmes: Finning Tractor and Equipment Company, Teck Corporation, British Columbia Telephone Company, and Air Canada.

Hindy Ratner
Extension Curator, Museum of Anthropology

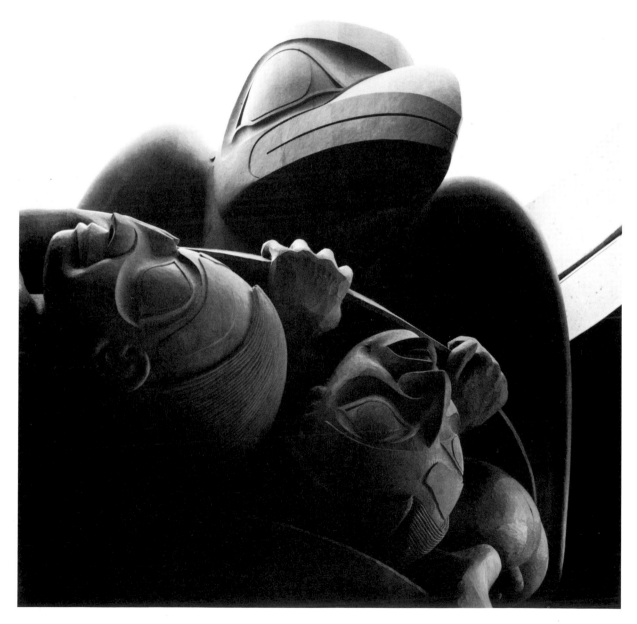

Figures 3, 4. The Raven and the First Men, yellow cedar sculpture, 1980.

# Foundations and Directions

*I think the dialogue between me, a product of urban twentieth-century North American culture, and the conventions of nineteenth-century Haida artistic expression, has produced some quite remarkable objects.*

Bill Reid.

Acclaimed as a master artist, goldsmith, carver, writer, and spokesman, Bill Reid is often considered the very symbol of the Northwest Coast Indian art revival. He is the artist who, according to the eminent French anthropologist Claude Lévi-Strauss, has brought Northwest Coast art *into the world scene: into a dialogue with the whole of mankind.*[1] His art encompasses the range from an intricate bracelet to a massive mortuary pole; from a sterling box inspired by a museum artifact to a contemporary necklace in gold and diamonds. His silver and gold jewellery gleams on the wrists of friends and patrons, while his bronze Killerwhale smiles ferociously at visitors to the Vancouver Aquarium. In the Haida community of Skidegate, Reid's house frontal pole, the first to be raised there in a hundred years, towers over the new band council office.

Reid's critics acknowledge his pivotal role in the revival. He was the first artist born in this century to master the complex principles of northern Northwest Coast design. Without question, the groundwork he laid for succeeding artists has reversed the demise of a great art tradition. Critics argue, however, that Reid's stature as an artist cannot rest solely on his historic achievements—the artistic merit of his work must also be considered. In this respect, critics speak of "copyism" rather than "dialogue"; they question whether Reid's art has developed beyond a resurrection of the essential Haida forms.

Every day, visitors encounter Bill Reid's monumental sculpture, **The Raven and the First Men**, at the University of British Columbia's Museum of Anthropology (figs. 3, 4). Many experience delight while others are awed by the hovering supernatural Raven. Their responses affirm the power of Northwest Coast art to touch the emotions of people from different cultures. But the sculpture, completed in 1980, cannot be understood solely in the context of nineteenth-century Haida art. Reid has blended the ancient sculptural and mythological traditions of the northern Northwest Coast with European naturalism, contributing qualities of individual expressiveness and movement to the Raven and human forms. At the same time, the sculpture's theme—the origin of mankind—has cross-cultural and even archetypal significance. In this and other works, Reid reveals the contradictions of his own experience as a twentieth-century individual with a foot in each culture.

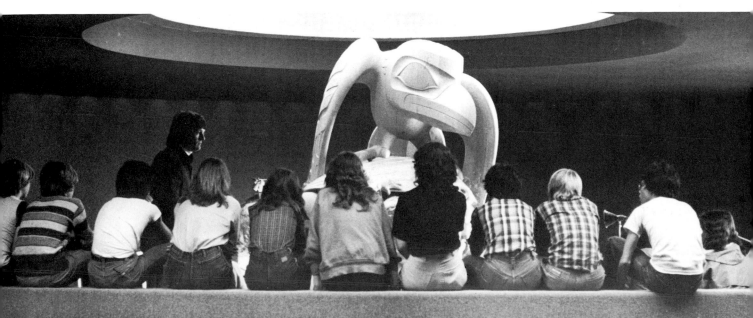

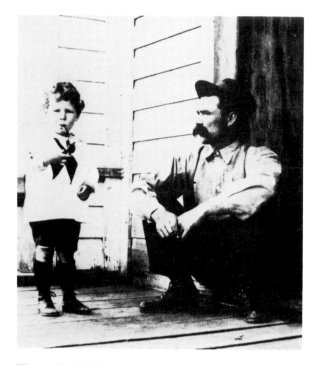

Figure 5. Bill Reid as a young boy with his grand-father, Charles Gladstone, c. 1923.

The art world calls him Haida, while Bill Reid calls himself *just a middle-class WASP Canadian.* He was born in Victoria in 1920, his mother a Haida from Skidegate Mission, his father a Scottish-German American. Technically, Reid is not Haida. By marrying a non-Indian, Reid's mother Sophia lost official native status for herself and her future offspring. This was determined by Canadian law as embodied in the Indian Act, a patrilineal system which contrasted with the Haida tradition of tracing descent through the mother's line. Even before her legal change in status occurred, however, young Sophia Gladstone's self-image was profoundly influenced at the Methodist residential school she attended near Chilliwack. Reid writes, *My mother had learned the major lesson taught the native peoples of our hemisphere during the first half of this century, that it was somehow sinful and debased to be, in white terms, an "Indian," and certainly saw no reason to pass any pride in that part of their heritage on to her children.*[2]

Reid's family transplanted its roots several times. He attended kindergarten in Victoria (taught by Emily Carr's sister Alice), carried on through elementary school in Hyder, Alaska and Stewart, B.C., and completed high school back in Victoria. Raised entirely in the European/North American society of his father, Reid was a teenager before he was aware of being *anything other than an average Caucasian North American.*

It was as an adult that Reid chose to educate himself in the native half of his inherited culture. In 1943, when Reid was in his early twenties, he at last got to know his Haida grandfather Charles Gladstone (1877-1954) personally, although he never knew his grandmother Josephine. Charles Gladstone (fig. 5) was the last in a direct line of Haida silversmiths who had learned their craft from their elders. He lived and studied in his youth with his uncle, the renowned artist Charles Edenshaw (c. 1839-1920, fig. 6) and, on Edenshaw's death, inherited his tools. Gladstone never achieved the artistic heights of his extraordinary uncle. He was, however, known as a commend-able silver engraver and argillite carver, as well as an expert boat builder. Through his friend-ship with his grandfather, Reid began what has become a lifelong series of visits to the Queen Charlotte Islands, and gradually started to iden-tify with the Haida people he met who remem-bered and had pride in their past traditions.

In the years following his early acquaintance with Gladstone, Reid moved to eastern Canada to further his career as a radio announcer. He had already been employed in commercial radio for eight years, and now, in 1948, began his ten-year association with the Canadian Broad-casting Corporation, starting with Toronto sta-tions. Three and a half years later, he returned to Vancouver to continue broadcasting. The death of Charles Gladstone in 1954 prompted him to write his first piece concerning the native peo-ples of the Northwest Coast. **Totems**, an impor-tant television film documentary written and narrated by Reid, recorded the salvaging of totem

poles from abandoned villages on the Queen Charlotte Islands. Another film focused on the 1956 Vancouver Art Gallery exhibition, **People of the Potlatch**. Yet Reid himself notes that this interest in his maternal ancestors was experienced from an outsider's or *non-Indian* point of view during his broadcasting career.

While living in Toronto, Reid discovered the Royal Ontario Museum's collection of Northwest Coast art. One work in particular, the great Haida totem pole from his grandmother's birthplace of Tanu, commanded Reid's attention and deeply affected his new-found connection back to the art of his ancestors. With the intention of continuing the Haida jewellery tradition as he knew it—primarily from bracelets worn by his mother and aunts and made by his grandfather and John Cross—Reid enrolled in a jewellery-making course offered by the Ryerson Polytechnical Institute in Toronto. There, he spent two years studying conventional European jewellery techniques under the direction of a London-trained goldsmith, James Green. He followed this up with a partial, year-and-a-half apprenticeship at the Platinum Art Company in Toronto, still working in the evenings for the CBC.

Reid's training in modern jewellery and developing interest in the work of leading contemporary North American designers gave him a new career direction. He returned to the west coast in 1951, to establish himself as a designer of contemporary gold, platinum, and diamond jewellery. The strength of the old Haida forms, however, exerted a pull that he could not resist. On a trip to the Queen Charlotte Islands soon after his return to Vancouver, Reid saw a pair of bracelets owned by one of his great-aunts and engraved by Charles Edenshaw. The bracelets so impressed him that he felt a renewed inspiration to devote his own creative energies to Haida jewellery, expanding the art by means of the European techniques he had learned. He established a basement workshop in his home and used his spare time to create, not only bracelets, but also earrings, brooches, rings, and boxes. With these objects he began to develop his knowledge of the dynamic structure of Haida form.

Figure 6. Charles Edenshaw at his carving bench, 1907.

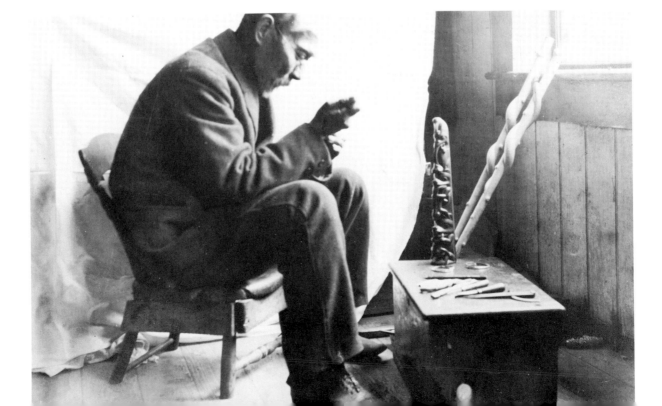

# Unlocking the Secrets

In a tribute to the artist written for the occasion of Reid's 1974 retrospective exhibition, art historian Bill Holm declared, *Bill found the dry bones of a great art and—shamanlike—shook off the layers of museum dust and brought it back to life.*[3] It was a task that had to start far from his mother's and grandfather's native villages, in the museums that now house the finest works of Northwest Coast art. The "museum dust" that had settled over Haida artistic traditions through seven decades of neglect, however, was not easily brushed away.

When Reid began his task in the early 1950s, knowledge of the highly conventionalized system of "rules" that characterizes northern Northwest Coast two-dimensional design had been lost. Self-taught Haida craftsmen of this period who were making a living carving argillite, silver, and wood for sale lacked an understanding of design principles essential to the continuity of a vibrant art. Of course, the carved and painted surfaces of nineteenth-century artifacts in museums still contained clues about design elements, composition, and colours. But the complete, flourishing Haida culture which sustained the art and provided the impetus for its expression had broken down by the late 1800s under the cumulative impact of colonization. The population had been decimated by the ravages of introduced disease. A decline in the fur trade and the increasing dependence of native people on a wage economy contributed even more to the force of this impact. In 1884, an amendment to the Indian Act prohibited the potlatch, a central institution of Haida society in which the art played a major role. This amendment was not repealed until 1951. As a result, the impetus to master the traditions and pass them on could not survive.

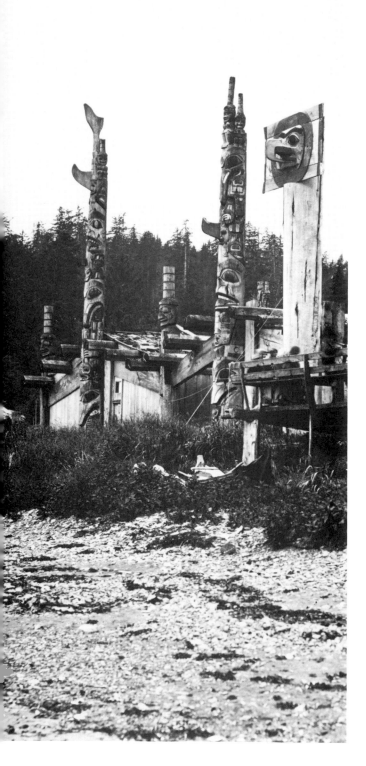

Figure 7. The Haida village of Skidegate, 1881.

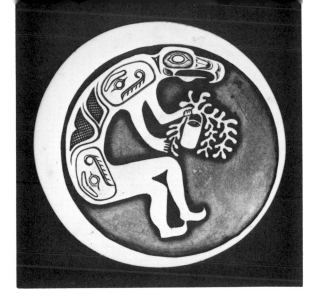

Figure 8. Sterling brooch, The Woman in the Moon, c. 1954 (4.8 cm. diameter)

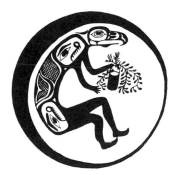

Figure 9. Tattoo mark design drawn by Wi'ha (in Ravenhill: plate 1, figure IV).

Through the study of northern Northwest Coast objects in museum collections and ethnographies written by the early anthropologists, Bill Reid began to reconstruct the formal rules of this complex tradition and understand the artistic process behind it. His early attempts at uncovering the design principles were conducted in a mechanical way. He remarks, *It was during this period that I built up an unrepayable debt to the late Charles Edenshaw, whose creations I studied, and in many cases shamelessly copied, and through those works I began to learn something of the underlying dynamics of Haida art which later permitted me to design more original pieces while still staying within the tradition.*[4] Although Edenshaw had died thirty years previously, Reid became, in essence, his apprentice, as his grandfather had before him. Anthropologists and collectors had maintained extensive contact with Edenshaw, and the result was that a large body of his work was now visible in museums and reproduced in books. Reid's method of copying the master's art was a traditional way of learning Northwest Coast design. It remains an important technique for young artists today.

With the work of *great-uncle Charlie* as his inspiration, Reid *had to teach his hand to draw what the eye could barely glimpse and the mind scarcely grasp.*[5] At this stage in his career his commitment was not to the mythological or ceremonial aspects of the art; it was an attraction to the aesthetic of the forms alone. He was convinced that Edenshaw had taken northern Northwest Coast art to its ultimate heights, and all he could contribute himself was to use the European jewellery techniques he had learned, applying the best of the old Haida designs to this new medium. Making light of his early efforts, Reid notes, *I admit the first thing I made was a very funny-looking bear, who didn't bear any relationship to anything, Haida or otherwise. Maybe that's what convinced me there was nothing new that could be done!*[6]

For several years Reid was dependent on the few Northwest Coast art books available in the 1950s. Together, these books provided a sufficiently wide selection of photographs and illustrations that he could pore over by the hour and attempt to reproduce in silver, gold, wood, and argillite. Alice Ravenhill's **A Cornerstone of Canadian Culture**[7] contains dozens of drawings and designs, many taken from photographs of artifacts in the British Columbia Provincial Museum and other museum and private collections. Books by the anthropologists John Swanton, Marius Barbeau, and Robert Inverarity are similarly illustrated.[8] Reid used several of the designs many times over in his early jewellery. Around

1954 he created numerous sterling brooches entitled *The Woman in the Moon* (fig. 8). Varying somewhat in size and detail, they are copies of a tattoo-mark design drawn by John Wi'ha, a Skidegate Haida (fig. 9). Reid's gold Raven brooch (c. 1954, fig. 10) and gold Dogfish brooch (c. 1959, fig. 11) also derive from images of tattoo marks drawn by Wi'ha and Charles Edenshaw respectively, and reproduced in Swanton (fig. 12).

In Franz Boas' **Primitive Art**,[9] Reid first became aware of the existence of a unique painted bent-corner box, a *masterpiece whose outstanding qualities were apparent even in the small, inaccurate, unfinished rendering which was illustrated there.*[10] Its painted design has intrigued scholars since the box was first collected by Lt. George T. Emmons in the 1880s at Chilkat (fig. 13). Reid has copied the design in different media, including silver (1964, fig. 14).

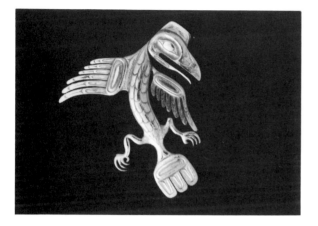

Figure 10. Gold brooch, Raven, c. 1954 (6.3 x 5.4 cm.)

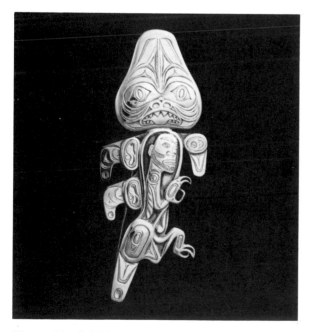

Figure 11. Gold brooch, Dogfish, c. 1959 (8.2 x 3.3 cm.)

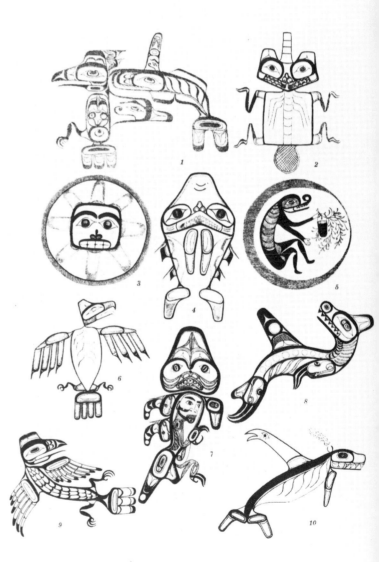

Figure 12. Tattoo mark designs (in Swanton: plate XXI).

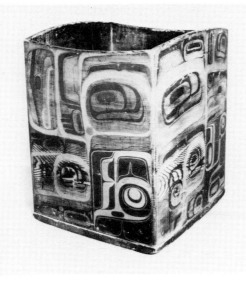

Figure 13. Painted bent-corner box.

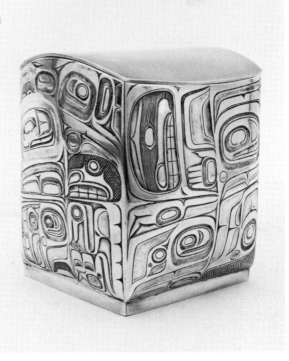

Figure 14. Sterling box with lid, 1964 (10.0 x 9.0 x 8.8 cm.)

It was not only in the pages of books, but also in the crowded cases of the old British Columbia Provincial Museum, located in the basement of the Parliament Buildings in Victoria, that Reid sought out the exceptional pieces from which he could unlock the secrets of the old forms. He spent hours looking at objects that later proved influential in his own work, but he says that *it took a great many years to find out why I was looking at them with that intensity*. The process by which he began to see the possibilities for his own creativity in this intellectualized art tradition is best expressed in his own words: *One day I just did something that didn't relate to the old designs. It was quite an amazing experience to look at it and realize that it was not too bad, and that I could begin to create if not new, at least different interpretations of the old forms…. I can remember, for instance, that I thought that all ovoids had flat bottoms. It was quite an amazing revelation to have my eyes opened to realize that they didn't have—they were a much more interesting shape than I thought they were. And I began to see the significance of the ovoid, the power that's compressed into that very simple shape. It was a series of constant discoveries for a period of a* *decade or so, and I eventually began to understand something of the complexity and differences that can be derived from these basic forms out of which Northwest Coast art is constructed.*[11]

While Reid was making his discoveries, Bill Holm, a young American scholar from Seattle who later became the curator of Northwest Coast Indian art at the Thomas Burke Memorial Washington State Museum, was reaching similar conclusions. As a graduate student in art history, he analyzed almost four hundred Haida, Tsimshian, Tlingit, and Northern Kwagiutl artifacts by Keysort cards, recording the incidence of specific design characteristics. In addition, he had spent many years since the 1940s making masks and ceremonial objects in Northwest Coast styles. By these methods, Holm learned the highly organized system of design principles to which the art owes its structure. He created the vocabulary now widely used to describe the individual elements and assess artistic quality. The results of Holm's studies were published in 1965 as **Northwest Coast Indian Art: An Analysis of Form.**

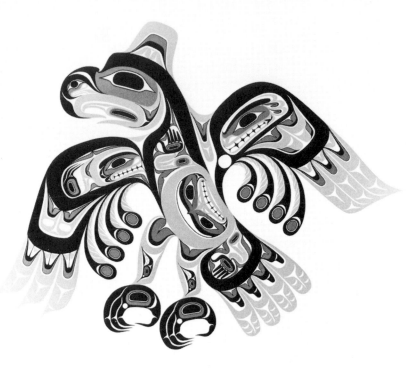

Figure 15. Reid's silkscreen print, Haida Thunderbird— Skiämsm, 1981, shows formline, ovoid, and u-form elements. Red, blue, and black on buff. Edition of 195 (76.0 x 71.0 cm.)

Holm and Reid reinforced each other's findings. They found that chief among the design principles is the concept of a continuous primary **formline** (fig. 15). The formline, usually painted black, is a broad band that swells and tapers as it outlines the main shapes. There are additional design units which can be arranged and varied in proportion to fit the requirements of space and representation. Integral motifs of the formline are the **ovoid** and **u-form**. They are used to define eyes, ears, and joints, and serve to integrate positive and negative space within a design. Ovoids can vary in shape from elongated to circular, but a well-executed classic ovoid in the northern style has a gently rounded top, slightly concave bottom, and sides that expand outwards from the bottom to the top, the whole having rounded corners.

The design elements and their variations, together with secondary and tertiary components, are only part of the rules an artist has to master. Designs range from realistically proportioned figures to highly abstracted motifs, depending on an artist's rearrangement of the elements representing body parts. Thus, the way in which elements are put together is also governed by set rules. This includes the control of negative spaces created by the positioning of elements. Colour use was similarly formalized, prescribing the application of black, red, and blue-green.

It may appear that the rules and conventions of northern Northwest Coast art are so strict as to stifle individual expression. In truth, the constraints are characterized by great variability, and compel rather than restrict personal creativity. Reid eloquently describes the vitality of the forms and their challenge for the artist: *It is the conflict between this rigid discipline and the genius of the great artists which gives such dynamic power to the images…. If every structure, be it box or totem pole, spoon handle or rattle, must have for every thrust a counter thrust, then each object becomes a frozen universe, filled with latent energy. The basic lines of a box design start with a major image, rush to the limits of the field, turn back on themselves, are pushed and squeezed towards the centre, and rippling over and around the internal patterns, start the motion again. Where form touches form, the line*

10

*is compressed, and the tension almost reaches the breaking point, before it is released in another broad flowing curve.... All is containment and control, and yet always there seems to be an effort to escape.*[12]

Reid and Holm speak about the *logic* of the art, expressed through the rules. The choices an artist can make to "escape" from the control of the design elements and their relation to each other are limited. If the essential formlines and other components are not used within the system, the structure, and the logic, collapse. To extend beyond the logic, therefore, is to balance the constraints of this highly structured tradition with the courage to stretch them to new limits, new logic. A masterpiece of Northwest Coast art not only shows a mastery of the rules, but transforms the conventions into an individual expression of what is possible. The artist's talent and genius, the emotional energy he infuses into the piece, and his unexpected outlook often define the greatest works.

The logic of Northwest Coast art is also expressed through apparent double meaning. The supernatural ability of humans and animals to transform at will into each others' forms, so dramatically recounted in legends and performed in masked dances, is shown in some flat designs by portraying a being as part human, part animal. A position or distortion that is illogical from an anatomical point of view thus becomes logical in Haida art. Creatures are represented at the same time from the front and the side, from without and within. They are contorted to fit the shape of object they decorate, so that arms emerge from ears, faces from tails: a frog and human share the same space, so that the frog's legs are also the man's arms. Faces seem to appear everywhere, their placing determined by the artist's imagination coupled with stylistic convention. Eye and joint designs can be identical. Two shoulder joints become the eyes of a face within the body cavity that is completed by ears, nose, and mouth. Reid comments: *When these things are right, they have their own extremes.*[13]

Through his independent study of northern Northwest Coast art and his gradual mastery of its principles, Reid achieved a level of understanding shared by few. He could not only recognize, but also create in his best works, a balance between form and freedom: *That's really what it's all about. That's why so much contemporary revival doesn't work. You have to push a carving to the ultimate, beyond what seems immediately logical.... And you keep pushing and pushing until you finally arrive at that point where it all comes together, where one area relates perfectly to another. And that point, somehow or other, determines itself.*[14]

Figure 16. Haida interior housepost from Skidegate, 1881.

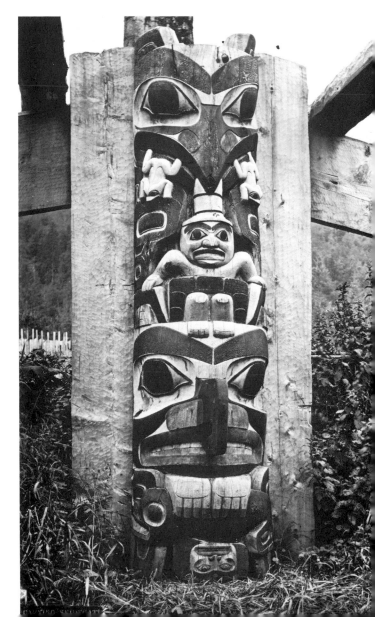

Figure 17. Bill Reid using the repoussé technique
to create a silver bracelet.

# New Dimensions of Technique

The creation of fine art in the northern Northwest Coast tradition depends not only on a controlled subtlety of form, but on the very precision of line that brings the form into being. As Reid points out, one is not complete without the other: *It is the direction of the line, the expression of the curve, the purpose of the brush stroke that moves or excites us, but without that old casual mastery of technique, the message is muddled and obscure, or so poor in the shades of meaning that constitute human communication, that it becomes meaningless, or even worse, boring.*[15]

Reid's recognition of the traditional standards of craftsmanship in work by leading nineteenth-century artists, and his subsequent role in restoring these standards in his own work, have been important in helping to place Northwest Coast art on the world stage. Furthermore, the goldsmithing techniques he commands have enabled him to push beyond the possibilities known to past masters. Through repoussé, casting, soldering, and silver overlay, Reid has extended Northwest Coast jewellery into three dimensions. Past technology only allowed shallow engraving of designs on to the metal's surface.

Silver was known to the native people of the Northwest Coast from first contact. It was not widely used as an art medium, however, until between 1850 and 1880, when silver bracelets were made for personal adornment, as potlatch gifts, and for sale to non-Indians. The Haida jewellery engravers were the masters of their art, led by the prolific Charles Edenshaw. His bracelets were traded along the entire coast from Alaska to Vancouver Island, and his designs were copied by other artists.[16] Reid believes that Edenshaw probably reinvented the technique of metal engraving, having seen European engraved objects but never the process by which they were made. He made his own tools with sharpened points of steel set into handles, and held the graver in the same position he used when carving wood with a crooked knife. Reid sees the method as *absolutely impossible to do*, yet points to the beautiful, powerful bracelets in museum collections that provide amazing proof of his great-uncle's success (fig. 18).

Figure 18. Sterling bracelet by Charles Edenshaw (c. 1839-1920), Bear (6.0 cm. diameter x 4.1 cm.)

Figure 19. Sterling bracelet, Tschumos, c. 1958 (6.5 cm. diameter x 4.9 cm.)

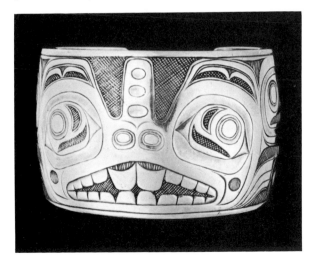

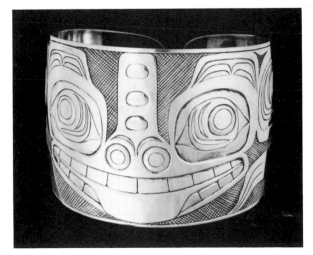

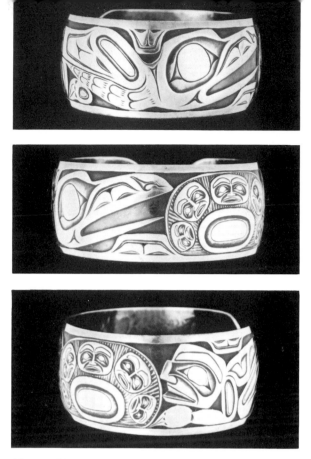

Figure 20 a-c. Sterling bracelet, The Raven and the First Men, c. 1956 (6.3 cm. diameter x 2.5 cm.)

Figure 21. Gold box with Bear design on sides, Killerwhale design on lid; lid surmounted by Eagle, 1967 (13.3 x 11.0 x 10.2 cm.)

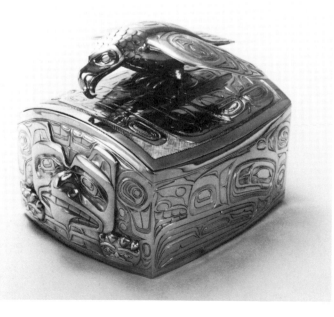

The early gold and silver jewellery made on the Northwest Coast consisted almost entirely of bracelets made by melting down coins, preferably American silver dollars. The liquid metal was poured into moulds and the resulting ingots were hammered into strips: these were then shaped into bracelet form using wooden benders, and commonly engraved with the family crest of the wearer. Bill Reid followed a similar procedure in his earliest jewellery, except that he used manufactured sheet gold and silver, a professional engraver's block, and modern engraving tools. He enhanced his engraved work with carving and chasing techniques to provide some depth. One example from his early period is a silver bracelet engraved with a Tschumos (personified snag of wood) design adapted from Edenshaw (c. 1958, fig. 19). Another is a silver bracelet that Reid's grandfather Gladstone only half-finished before he died in 1954. Reid completed the engraved design.

Also in the 1950s, Reid began using the technique of silver overlaid on silver to create his "black and white" pieces. He achieved an effect of shallow depth by raising the flat motifs from their background (c. 1956, fig. 20). The entire piece was blackened through oxidization, then polished, leaving the motifs shiny and the background dark.

Some pieces, such as his gold Raven brooch (fig. 10), are built up of segments of sheet metal that Reid preformed and then joined by means of silver and gold soldering. The Eagle that surmounts a gold box made in 1967 (fig. 21) was assembled from approximately thirty such segments. The result is a much more technically complex work than could ever be achieved by the engraving method alone. Reid also used the European technique of gem setting to inlay decorative materials—abalone shell and fossil ivory—into his jewellery. The gold Hawk brooch (1971, fig. 22, Plate VII) displays a radiating band of abalone around its rim and flashing abalone eyes and teeth. The brooch is reminiscent of the traditional Haida frontlets worn by chiefs.

Reid first used the technique of repoussé in the late 1950s, bringing a rich dimension of sculptural relief to his creatures depicted in silver and gold. The word "repoussé" means to push back. A negative image is formed and shaped by hammering out the design on sheet silver or gold, which is imbedded in pitch for support. The piece is then reversed, the pitch scraped off, and the final contours achieved by hammering from the front. Thus, a repoussé Beaver appears to thrust his face out from the more shallowly engraved forms decorating a gold box (1971, Plate V), while a complete repoussé Frog has a liveliness of its own (1971, fig. 23).

The repoussé technique tends to give a naturally rippled texture to the surface being hammered. Reid has enhanced this quality in many works by producing a hammered surface as a deliberate effect. The gold and abalone Eagle brooch (1970, see cover photo) and the gold Beaver and Eagle bracelet (1970, Plate II) are given added brilliance by fine hammering with a small punch, suggesting the adzed finish of much Northwest Coast wood carving.

In 1970 Reid began using the lost-wax method, in which a carving is made of wax before it is cast in gold. With this technique, Reid could produce an entire piece such as the gold Grizzly Bear medallion of 1972 (fig. 24). He could also use the method to create separate elements of more complex works. The Killerwhale mounted on the lid of Reid's gold Beaver and Human box (Plate V) is the only element of the box made in this way. Similarly, the boldly designed Bear that forms the container for Reid's Bear Mother dish (1972, Plate IV) has head and feet cast by the lost-wax method, and the flowing mother and cub grouping that surmounts the lid of the dish was made in the same way. A more recent work is a gold Dogfish Woman pendant (1983) transferred from the carved boxwood original (1982, Plate VI) using a silicone rubber mold and the lost-wax process. The casting technique brings to these works a fluid plasticity that complements Reid's use of Haida form.

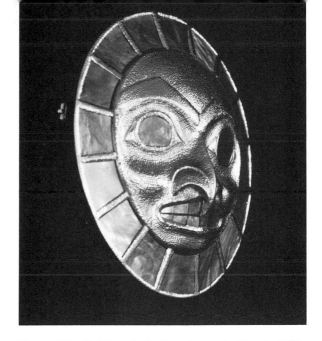

Figure 22. Gold and abalone brooch, Hawk, 1971 (5.8 x 5.4 cm.)

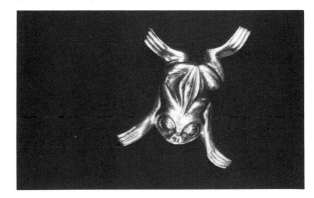

Figure 23. Gold brooch, Frog, 1971 (3.8 x 3.1 cm.)

Figure 24. Gold medallion with chain, Grizzly Bear, 1972 (5.1 cm. diameter)

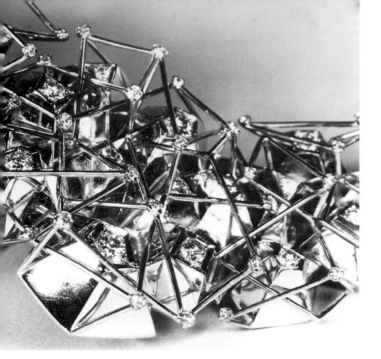

Figure 25. Detail of gold and diamond necklace, 1969 (16.8 cm. diameter)

Figure 26. Sterling box with hinged lid, Raven motif, 1969 (9.5 x 8.0 x 4.3 cm.)

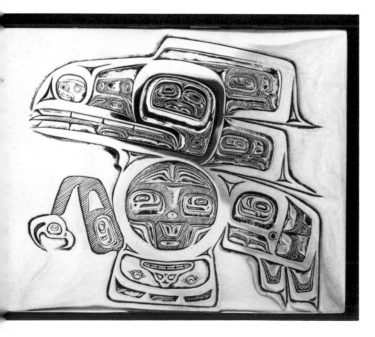

Reid has created jewellery in the contemporary, international style as well as in Haida tradition. In 1968 he spent a year at the Central School of Design in London, England on a Canada Council senior fellowship to improve his goldsmithing techniques. Reid created one of his most important pieces during that stay, an intricate necklace of gold and diamonds (1969, fig. 25, Plate IX). His understanding of Haida logic inspired the idea behind this modern piece, two complementary forms occupying the same space. The forms are essentially two connected necklaces, one of three-dimensional pyramid shapes and the other of wire. A brooch is also hidden within the necklace and can be removed. There is a tight structure behind the myriad lines and angles—as with a classic Haida design painted on a box, all its parts have *to fit together perfectly to function.*[17]

Returning from England in 1969, Reid set up a jewellery workshop in Montreal and remained in that city for three years. His London experience had an enormous influence on all his subsequent production, which included pieces of both Haida and contemporary design. In Montreal, he created what he considered the best pieces of his career to that date, among them the gold Beaver and Human box and the Bear Mother dish already described. His other favourite works from this period include a carved and chased silver box with Raven motif (1969, fig. 26), an argillite panel pipe (1969, fig. 27), and a second contemporary necklace of silver and white gold (1972). The necklace was purchased for the Jean A. Chalmers Collection of Contemporary Canadian Crafts. In 1970 Reid also created his famous, tiny boxwood carving interpreting the Haida legend of the Raven discovering mankind in a clamshell (fig. 28). The massive version of this same carving was completed ten years later for the UBC Museum of Anthropology.

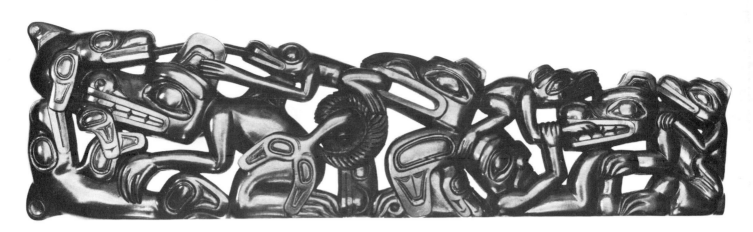

Figure 27. Argillite panel pipe, 1969 (27.0 x 7.6 x 1.5 cm.)

Figure 28. Reid holds his boxwood carving, The Raven Discovering Mankind in a Clamshell, 1970 (7.0 x 6.9 x 5.5 cm.)

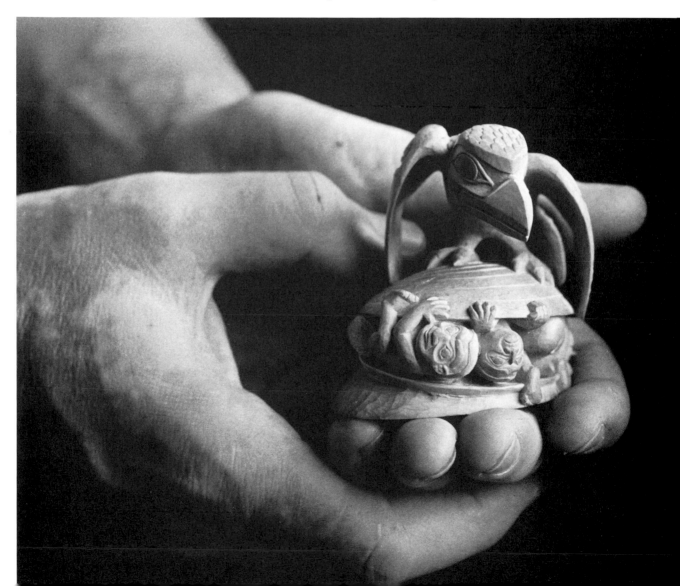

Figure 29. Yew wood pendant with copper, abalone, glass trade beads, and polychrome, Wolf, 1977 (8.4 x 7.2 cm.)

Reid considers himself primarily a goldsmith, but in addition to his jewellery he has created massive and miniature works in wood, ivory, argillite, and bronze (1977, fig. 29; 1969, fig. 30; 1966, fig. 31). He has also produced a series of limited edition silkscreen prints and a collection of pencil drawings depicting the myth creatures traditionally brought to life by Haida storytellers. Reid made his first set of silkscreens in 1973. Although the silkscreen medium does not feature significantly in his artistic output, he was among the first Northwest Coast artists to use prints as a way of bringing the traditional forms to wider public attention (fig. 15). Reid's training in jewellery techniques influences his work on paper and in other media. The procedure that guides his goldsmithing, his familiarity with specialized tools and difficult techniques, and his ability to invent new solutions to problems carry through to his work in any medium, whether it is two- or three-dimensional, a brooch or a totem pole. It is the very nature of northern Northwest Coast art that its essential form can be successfully applied in proportion to any scale.

It was in 1957, after he had begun to establish his career in jewellery making, that Reid started to develop his wood-carving skills. He was invited by the anthropologist Wilson Duff to spend two weeks at the British Columbia Provincial Museum carving a copy of a Haida pole. There, he worked alongside the master carver Mungo Martin (c. 1881-1962), informally learning some of the traditional wood-carving techniques of the Southern Kwagiutl. Soon thereafter, Reid was given the opportunity to recreate a section of a Haida village for the University of British Columbia campus, which allowed him to quit his broadcasting career and devote himself full-time to Haida art. Perhaps it was the monumentality of Reid's jewellery design, together with his obvious appreciation and knowledge of Haida sculpture, that prompted the anthropologist Harry Hawthorn to make this offer to an artist with such limited carving experience. Reid and his assistant, Kwagiutl artist Douglas Cranmer, spent

three and a half years on the Haida House project, from the spring of 1958 to January 1962. *Leaving the twentieth century behind*, they ensconced themselves in the carving shed on the outskirts of the university to produce two house frontal poles, an interior house post, a single and a double mortuary pole, a Beaver memorial pole, and a massive Sea Wolf figure. At the same time, Reid supervised the building of a winter dwelling and a mortuary house, both of traditional post-and-beam construction (Plate I).

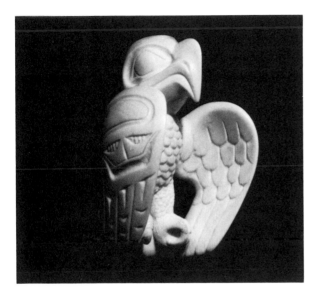

Figure 30. Fossil ivory pendant, Eagle, 1969 (5.1 x 3.8 cm.)

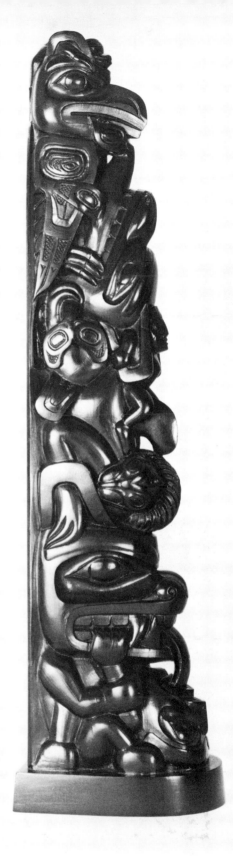

Figure 31. Argillite totem pole, Grizzly Bear, Human, Sea Wolf, Killerwhales, Human, Eagle, and Frog, 1966 (31.8 cm. high)

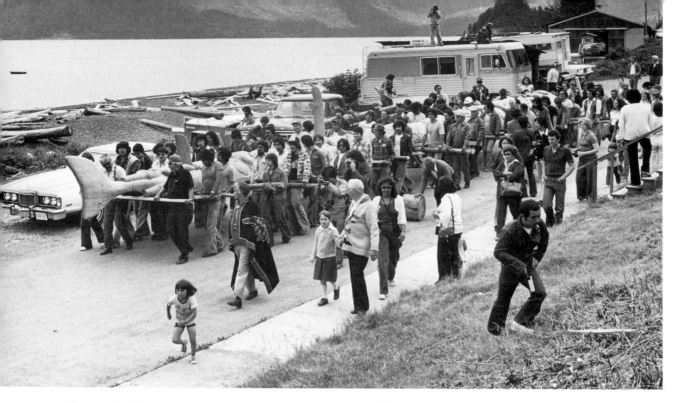

Figures 32, 33. Raising Bill Reid's totem pole at Skidegate, 1978.

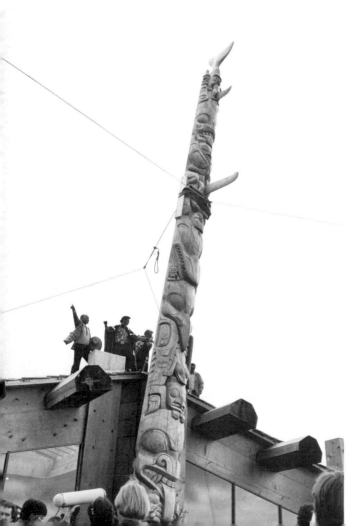

Through the Haida House project, Reid taught himself the art of Haida totem pole design and carving. One of the most personally significant works he created after that project was a frontal pole over seventeen metres high for the new Skidegate band council office (figs. 32, 33). He began the work alone in 1976, and was assisted in the last five months by Gary Edenshaw; Robert Davidson designed and carved the forms embellishing wings and fins. The project was completed in 1978. Reid's pole, intended as a memorial to the Haida of the past, was the first to be raised in his mother's village in more than a century. The sculptured figures represent the legendary beings he so often chooses to depict in his art: the Grizzly Bear and Bear Mother with their cubs; the Raven and the Frog; Nanasimgit, who rescues his wife, kidnapped by the Killerwhales; the Dogfish, one of the crests of Reid's grandfather and, perched on the top of the pole, the traditional three Watchmen.

Transposing his ideas into monumental sculptures of wood and, recently, bronze has usually involved the skilled assistance of other carvers and specialists. Reid has been plagued most of

his life by spinal problems, and in 1973 suffered the onset of Parkinson's disease. In order to fulfil the commission from his long-time patron Walter Koerner for the massive carving, **The Raven and the First Men** (fig. 3), Reid guided the hands of stronger men, native and non-native. Vancouver sculptor George Norris used Reid's original boxwood carving to work up a one-third-scale clay model, calculated the dimensions of the large carving, and began roughing in the sculpture. The block of wood itself was fabricated by wood technologists from 106 yellow cedar beams laminated together and weighing four and a half tons. Gary Edenshaw, George Rammell, Jim M. Hart, and Reg Davidson each contributed their carving skills at various stages of the project, under Reid's close supervision. The sculpture was unveiled on 1 April 1980 by the Prince of Wales and dedicated by representatives of the Haida Nation on 5 June, further symbolizing its significance to both cultures.

Reid's recent works cast in bronze include his giant leaping Killerwhale, located at the Vancouver Aquarium, and his motion-filled frieze, **Mythic Messengers**. The latter, which adorns the entrance to Teleglobe Canada's international centre in Burnaby (1984, fig. 34), brings to mind his laminated cedar screen in the collections of the British Columbia Provincial Museum (1967, fig. 35) and the connected creatures of argillite pipes and raven rattles that inspired both works. Reid designed his bronzes on a small scale and proceeded through successive stages with the help of skilled specialists. The great, free-standing Killerwhale underwent several changes in design details as it was transformed from a ten-centimetre boxwood model (1983, fig. 36) to its 5.5-metre final cast form (1985, fig. 37). The symmetry and depths of lines and forms, and the fullness and volume of the overall shape had to be refined to better exploit the effect of light on the larger work. The plaster form of the whale was then sent to the Tallix Art Foundry in New York, where, over a period of seven months, it was cast, finished, and given a patina.

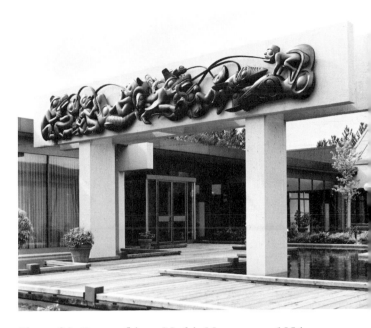

Figure 34. Bronze frieze, Mythic Messengers, 1984.

Figure 35. Laminated cedar screen, 1967 (213.0 x 190.3 x 14.6 cm.)

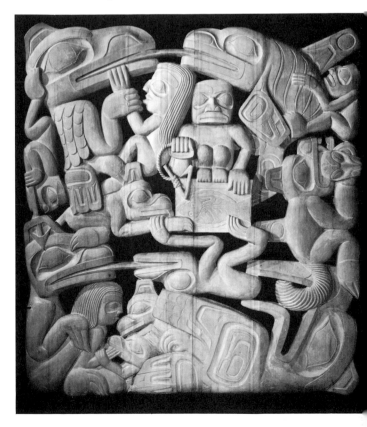

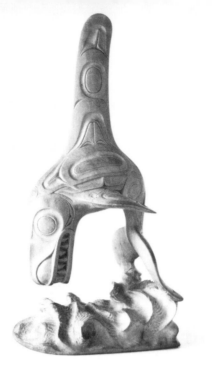

Figure 36.  Boxwood model, Killerwhale, 1983 (10.0 cm. high)

Figure 37.  Bronze sculpture, Killerwhale, 1985 (5.5 metres high)

As a practical and aesthetic innovation for Haida art, bronze seems particularly suited to the large-scale work of a jeweller experienced in designing with precious metals in miniature. Reid integrates Haida form with the intrinsic qualities and values of the metals, maintaining the same standards of precision and craftsmanship for bronze as he does for silver and gold.

Through the bronze medium in particular, the viewer may be drawn into seeing connections between Haida art, ancient Chinese bronzes, and the contemporary works of international artists. Such connections raise questions about the qualities that give certain works of art, derived from disparate art traditions, universal appeal. Offering us his suggestion, Reid takes us back to that essential balance between technique and creativity that spells craftsmanship. He writes, *One basic quality unites all the works of mankind that speak to us in human, recognizable voices across the barriers of time, culture and space: the simple quality of being well made.*[18]

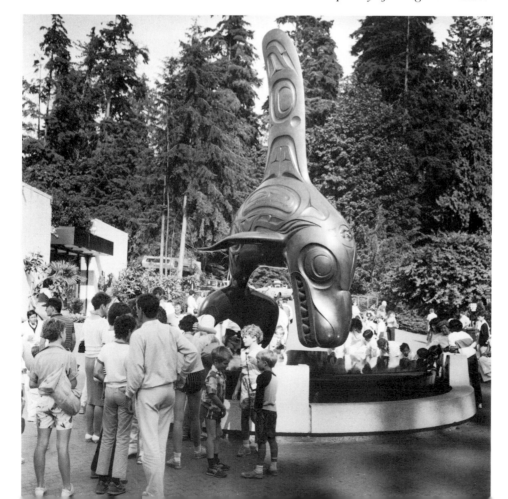

# Transforming Traditions

Only recently in its comparatively long history has Northwest Coast art been presented in museums and art galleries as equal to the great creative achievements of the world. Certainly, the Surrealist artists—Max Ernst, André Breton and others who "discovered" Northwest Coast masterworks in New York museum collections during the 1940s were unusual among their peers in their perceptive appreciation of the art's forms and visual puns. Many individual collectors and patrons have also been able to appreciate the art as connoisseurs, be moved by the excellence and beauty of the fine Northwest Coast works they own. Scholars, however, have shown a reluctance to separate the art from the cultural context that gave it meaning. The idea of art for art's sake, where individuals create objects to express personal as well as cultural aesthetic sensibilities, has been foreign to generally accepted notions of native art traditions.

**Arts of the Raven** marked a turning-point for Northwest Coast art appreciation in British Columbia. This exhibition, held in 1967 at the Vancouver Art Gallery, was organized by Doris Shadbolt with the assistance of Wilson Duff, Bill Holm, and Bill Reid, who used their well-trained eyes and intuition to select masterworks from leading North American collections. Special sections within the exhibition focused on Charles Edenshaw and the work of Reid and other contemporary artists. Shadbolt announced the show's message with confidence: *This is an exhibition of art, high art, not ethnology.*[19] Without ignoring the ethnological and historical aspects of the works, **Arts of the Raven** helped open viewers' eyes to Northwest Coast art as fine art.

Northwest Coast art was, in fact, only beginning to enter the wider public's consciousness at this time, in particular through an artistic revival that was most evident in the urban marketplace. This revival was stimulated by changing cultural and political forces in native and non-native societies. Most notably, growing tourist demand for souvenirs encouraged the production of native arts in a wide range of quality. The involvement of anthropologists and museums in Vancouver and Victoria gave the art increased publicity and support. Exhibitions, publications, and carving programmes—such as the ones that employed Mungo Martin and, later, Bill Reid and Douglas Cranmer—helped point public attention to the work of past and present artists.

By the late 1970s, the market for Northwest Coast art had become a several-million-dollar industry. It now involves at least two hundred professional native artists and many more casual producers, supported by a primarily non-native buying public. An added development in recent years has been the creation of art objects by contemporary artists, often at great personal expense, for use in potlatches and other cultural events in native villages. Northwest Coast traditions, whether expressed for the art market, museums, or dancing, have taken on a new significance in native and non-native societies alike.

Bill Reid's role in reviving northern Northwest Coast art has extended far beyond the private world of his jeweller's bench. As with the trickster/transformer Raven of Haida legend, Reid's original intentions brought about quite inadvertent and significant changes to the world around him. The main motive behind his work was to ensure lasting recognition for Haida artistic traditions. In reclaiming the art of the past for present use, Reid helped bring about a major artistic transformation. He is now hailed as the father of a Northwest Coast cultural "renaissance"—a renaissance whose substance he personally doubts.

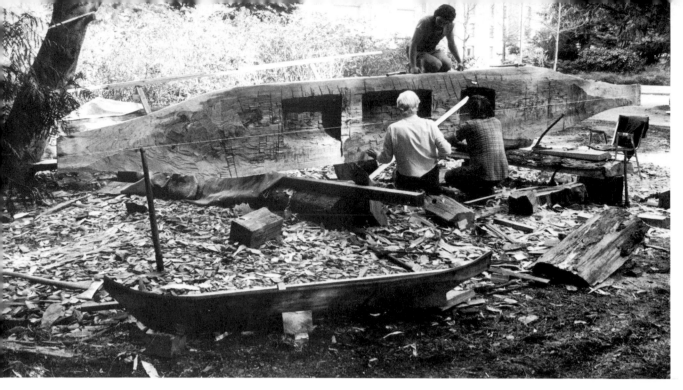

Figure 38a-d. Bill Reid, assisted by Gary Edenshaw, Simon Dick, and others, constructs a 7.5-metre inshore canoe. (a) The cedar log is shaped and hollowed. Intricacies of design are worked out using the 2.5-metre model canoe in the foreground. (b) Outside the Museum of Anthropology, the carved canoe is prepared for steaming while rocks are heated in a nearby firepit. (c) The canoe is partially filled with water and white-hot rocks placed inside. The hull is covered with matting to retain the steam. (d) The cedar hull gradually softens, and spreaders are inserted to stretch the canoe to its necessary width. On 10 October 1985, the completed canoe was ceremonially launched in Vancouver's False Creek. This project, co-ordinated by the museum with the financial assistance of Expo 86, gave Reid additional experience for his construction of an ocean-going canoe in 1986. The canoe was donated to the museum by Expo.

Reid brought back to the art a level of quality that gave younger master artists such as Robert Davidson a foundation on which to build their own understanding of Haida form. Other artists are learning directly from Reid by assisting him as apprentices or "hanging around," watching and participating. Most recently, Reid has worked with teams of local carvers at Skidegate, teaching and exploring the Haida art of canoe making.

The jewellery techniques Reid brought to Northwest Coast art, particularly for engraving, have since become the new tradition in accepted methods used on the coast. The old techniques practised by Edenshaw, Gladstone, and Cross have few practitioners. Still, Reid remains unique among Northwest Coast artists in his mastery of the more complex techniques he holds in his jeweller's bag of tricks.

Public awareness of Northwest coast art and culture has been enhanced by the power of Reid's words as well as his art. His text for **Out of the Silence** creates a poetic image of abandoned coastal villages, their past vitality still reflected in surviving remnants of fallen totem poles.[20] In other writings, including his essay in **Arts of the Raven**, Reid gives us a glimpse inside the old art through his experience of its profound and magical qualities. His eloquence commands attention when he addresses social and environmental issues affecting native people today, particularly on **Haada Gwaii**—the Queen Charlotte Islands.

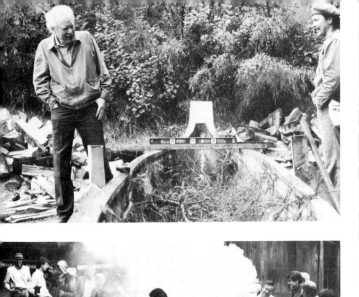

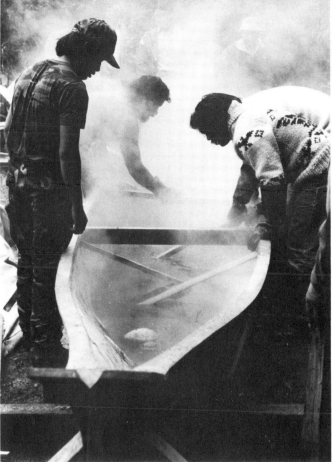

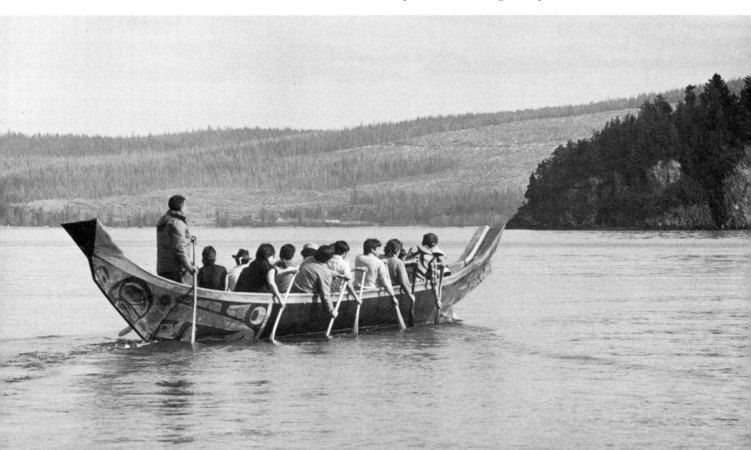

Figure 39. Fifty-foot ocean-going Haida canoe being paddled at Skidegate, April 1986.

The growth of public awareness meant an increased market for contemporary Northwest Coast art. In the 1950s, Reid sold his early pieces for *nickels and dimes*, and was only able to continue by working full-time for the CBC. It was several years before the market built up so that he could make jewellery and carving his livelihood. The attention that Northwest Coast art gradually began to receive from museum curators, gallery owners, and the buying public was due in no small part to Reid's and his fellow artists' dedication and perseverance in those first lean years.

Today, Reid's art is represented in public and private collections in Canada and around the world. Values of his work have soared, with fine pieces coming on the market for tens of thousands of dollars. Five Canadian universities have conferred honorary doctoral degrees on him for his contributions to native art generally. In 1977, Reid received the coveted $20,000 Canada Council Molson Prize, and in 1979 the **Diplôme d'Honneur** from the Canadian Conference of the Arts. The Polytechnical Institute where he began his studies of jewellery making honoured him in 1985 as the Ryerson Fellowship recipient. Most recently, in 1986, Reid received the prestigious Saidye Bronfman Award for Excellence in the Crafts.

With such testimony to his stature as an artist, why does Reid doubt the existence of the "renaissance" he is credited as stimulating? Instead of celebrating the revival, he declares it to be largely urban-based and anthropologist-created, not involving a meaningful renewal of native society. Reid himself has spent most of his lifetime on the periphery of that society, frequent visits notwithstanding.

Anthropologists describe Reid as a "bridge" between the new generation of Northwest Coast artists and the Haida masters of the past. Reid uses the same analogy, but ponders whether his bridge has become a one-way street: *We feed into the general population these objects which bring satisfaction and enjoyment to the non-native population, and we get money in return individually. But nobody sees beyond the images of the iconography to the people whose ancestors created this kind of thing.*[21]

From an initial focus on the aesthetics of Haida art, Bill Reid now speaks of the necessity of becoming involved with the native people themselves. He hopes the Haida eventually *return to the old cultures*, though not simply in terms of a renaissance of language, ceremony, and art. His vision has young people taking pride in the true accomplishments of their forbears and emulating them in new ways, so that native people can claim their place in the wider world while remaining distinctively Haida. Perhaps the art, expressing the essence of creativity, will provide one path toward *an appreciation of what is possible.*[22]

Reid's concerns exist side by side with his simple admission that, long ago, he was *possessed* by Haida art and has never been able to give it up. Far from demanding excuses, his creations justify themselves as integral, well-made objects that reveal the strength of Northwest Coast art in universal terms. Reid believes that Northwest Coast artistic achievements, like all great traditions, must now be considered the legacy of the world. He draws on his Haida and European heritage to inspire forms and ideas that are at once indigenous and international, traditional and innovative, artistic and political. Through his art, we can explore these apparent contradictions and, at the same time, make sense of Reid's achievements as a twentieth-century artist.

# Beyond the Essential Form

What standards can we use to judge the quality of Bill Reid's work? Anthropologists, critics, and even the artists themselves are asking questions that reveal uncertainties about how contemporary native art should be viewed. Should the art be placed in a separate category labelled "Indian," and judged by comparing new images with old? Or can this art, with roots in a non-Western cultural tradition, be judged by the same criteria as non-native works?

Some artists see the recognizable "Indianness" of native art as a boundary that confines the work to curio status or, at most, a simple rehearsal of old forms. In a conscious departure from the stereotypes of Indian art, Canadian modernist painters such as Robert Houle, Carl Beam, and Clifford Maracle are expressing themselves as individuals, sometimes using identifiable native imagery and at other times not. Their work demands to be judged on equal terms with that of non-native painters, making irrelevant the debates on their work's "authenticity" as "Indian."

Moving in a seemingly opposite direction, Bill Reid and his Northwest Coast peers place an emphasis on creating their art within centuries-old conventions of form and composition. Some artists go even farther in their exploration of ancestral traditions. Robert Davidson, Tony Hunt, and Joe David, among others, are striving to maintain or recreate a personally meaningful, native context for their art through language study, spiritualism, and ceremony. At the same time, they and Reid are clearly twentieth-century artists, immersed in the dominant culture of North America. They respond to the challenge of innovation and creativity inherent in both the structure of Northwest Coast design and the Western avant-garde. Their work cannot be categorized, then, as exclusively traditionalist or individualist. It has its roots in recognized styles of Northwest Coast art, but is part of new genres developing out of the contradictions and ambiguities of the present day.

To view mainstream, modernist forms of painting and sculpture as the only evolutionary direction for Northwest Coast art is to cast another mould into which native artists must fit if they are to be accepted in the modern art world. Contemporary Northwest Coast artists question the popular notion that the essence of art lies in discontinuity with tradition. Bill Reid, for one, uses the tradition as a means of personal artistic expression. He has moved from the position of an artist/historian, learning by copying, to a creator of original images in Haida and "universal" styles. His most recent works, which blend complementary elements of Northwest Coast iconography and Western naturalism, extend the definition of Haida art beyond its generally understood boundaries. Reid's best pieces remain recognizably Haida, but they do not rely on this aspect to be successful. They can also transcend their specific cultural context and be judged in the wider art world.

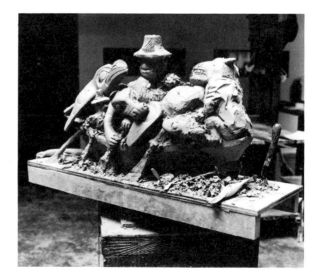

Figure 40. Unfinished clay model of Reid's forthcoming work, Mythic Canoe, 1986 (100.0 cm. x 58.0 cm. x 40.0 cm.)

Reid has stressed the artist's need for criticism. In traditional Northwest Coast societies as in any other, *Without an informed and critical public, the artists could never...have produced the great works they did.*[23] Yet Reid remains the most vocal of his own critics. Others shy away from applying universal standards, or profess not to understand native art. Moreover, public recognition of Reid's role in the Northwest Coast art revival has granted him a virtual superstar status that inhibits critical discussion of his work.

How does Reid judge his own art? On one hand, he believes that a design either works or it doesn't, and there is no way of explaining why. On the other hand, certain criteria do inform his personal critiques: quality of craftsmanship, mastery of form, balance of classic design principles with new elements, and the emotional impact or expressiveness of the piece. With characteristic candour, he divides his prolific output into four loose categories labelled *bad, derivative, playing it safe,* and *mature.* Many of these pieces he regrets having made, and would like nothing more than to *melt them down* or even *dump them into some appropriate part of the ocean!* In other pieces Reid acknowledges that he has achieved, through a dialogue with the material and the forms, the high standards he seeks in the *well-made object.* He feels that the richness of texture and vitality of form he has brought to these silver and gold pieces equal the best work of the traditional European gold- and silversmiths.

Bill Reid's categories suggest a way of critically approaching his art that focuses on the process by which he began to use the tradition creatively. Tradition and innovation are not isolated components in art, one belonging to the past and the other to the present or future. Both are parts of a continuum, and the artist builds one upon the other as he develops his art through experimentation and learning. Reid's work includes **copies**, derived directly from published designs and museum pieces; **adaptations**, which may continue to be *derivative* in design but also incorpo-

rate innovations in media, technique, and style; and **explorations** that demonstrate his original perceptions of Haida imagery and new uses of forms and techniques, as well as his play with the boundary between Haida and non-Haida art. His work, however, does not necessarily flow from copy to exploration in a chronological pattern of development. At varying times in his career, Reid has created exceptional pieces with attributes he may never surpass in later work: in other pieces he is less successful or is *playing it safe.*

## Copies

**Bill Reid: Beyond the Essential Form**, the Museum of Anthropology's exhibition of Reid's small works in precious metals, ivory, wood, and argillite, included several pieces that are copies of older Northwest Coast objects. Such copies allow us to evaluate Reid's interpretations by comparing them with the originals. The sterling brooches of *The Woman in the Moon* (c. 1954) and the gold brooches of the Raven (c. 1954) and the Dogfish (c. 1959) have been mentioned earlier in relation to their sources. Each piece received a three-dimensionality through its translation from book illustration to brooch, the gold Raven in particular being given added life by the effect of the raised body and meticulously crafted individual feathers. Another brooch (c. 1964, fig. 41), just over seven centimetres long, depicts a Beaver flanked by two Bears and two Eagles in a dense configuration. Based on a Haida shaman's charm of bone in the collections of the Royal Ontario Museum,[24] the gold copy has a new boldness achieved with the repoussé technique. Reid contributed more fluid, rounded forms and space-filling detail—two characteristics of his developing personal style.

Reid's 1964 silver rendition of the extraordinary painted bentbox in the Museum of Natural History, New York, was an attempt that, in the artist's own opinion, does not do justice to the

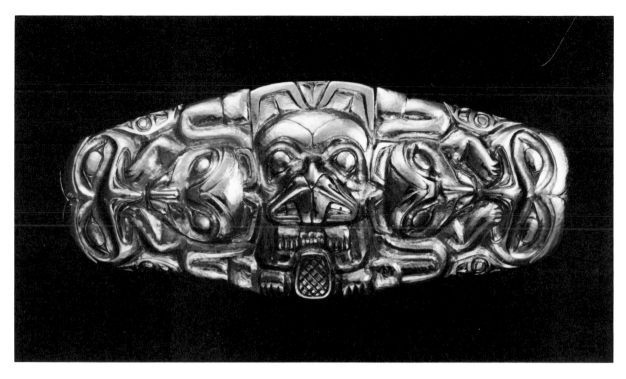

original (figs. 13, 14). The museum's box is painted with a masterfully conceived distributive design, explained by Charles Edenshaw as representing four episodes from the Raven myth, that continues to challenge our understanding of the "rules" of northern Northwest Coast art. Its most atypical quality is the division of each side into quarters, the lower right of these being painted solid black with red formline elements. Red is also used as the primary formline colour in the remaining three quarters of each side.

In his rendition, Reid transformed the original straight sides of the box into gently bulging walls that, together with a smoothly curved lid, create a greater unity between the container and its calligraphic design. Reinterpreting the painted box in the medium of silver, however, meant that Reid lost the original effect achieved through colour. A comparison of formline elements also reveals awkward elaborated ovoids or **salmon trout heads** in Reid's version. The units within these ovoids appear as disconnected elements, rather than being defined by the negative shapes that result from a formline pattern.

**Figure 41.  Gold brooch, Beaver, Bears, and Eagles, c. 1964 (7.2 x 2.9 cm.)**

Reid's 1969 silver box with hinged lid (fig. 26) illustrates a motif from the Raven screens of Hoonah, now in the collections of the Denver Art Museum. Reid's Raven design achieves the same overall form as the original but, as with the earlier such box, his approach is awkward and tentative in the form and placing of secondary and tertiary design elements. Thus, for example, the Raven's leg appears to be decorated with an elaborated ovoid and u-form, and the formline, which should be the positive shape defining these elements, recedes as background. This cannot be interpreted as the stylistic choice of the artist: rather, it demonstrates the logic of northern Northwest Coast two-dimensional art, that certain elements and relationships must be used or the structure loses its strength.

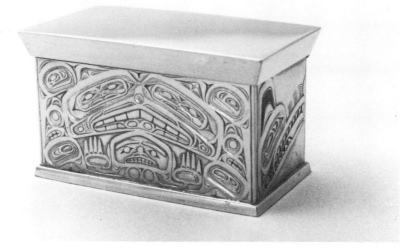

Figure 42. Gold box, Bear,
Human, and Wolf, 1973
(5.5 x 3.5 x 2.8 cm.)

The problem with the formline and its relation to negative space is less evident in Reid's gold bentbox (1973, fig. 42), which, in the artist's words, *sets out to do nothing but be a miniature Northwest Coast classical chest of gold.*[25] Using European goldsmithing methods, Reid reproduced the form of a chief's chest and added a hinged lid. The highly stylized split-image designs engraved and carved on the front and back conform to conventionalized older designs. The ends of the box represent different versions of a wolf's head. Each pair of designs appears alike at first glance, but on closer inspection shows some surprising differences. Reid has integrated his knowledge of Haida design grammar with precise workmanship in this piece, a traditional form that epitomizes the old aesthetic system. He returns to the concept of Northwest Coast boxes several times in his career, but in more dramatic reinterpretations.

The totem poles Reid carved with the assistance of Douglas Cranmer, and that now stand with two Haida house replicas behind the Museum of Anthropology (Plate I), blur the distinction between copies and adaptations in Reid's sculptural work. Reid combined his original designs with a repetition of figures from salvaged parts of old poles to create a synthesis of old and new. The first pole to be carved was the mortuary house frontal pole, in 1959. Except for the three Watchmen on the top, the pole is a two-thirds-scale copy of an older piece in the museum. This is the least successful of all five sculptures in its comparatively flat portrayal of the figures and over-compressed form. The towering frontal pole on the larger house stands in sharp contrast to the first. Completed in 1962, it was one of the last pieces to be carved in the Haida House project. Its well-proportioned, sculptural figures are new renditions of images seen in old photographs. They flow in and through one another in an expression of Haida logic and a demonstration of Reid's artistic development during the course of the project. The huge Beaver and Raven memorial pole (1960-61) was also designed by Reid. The bold-faced Beaver, with a Bear cub between his ears, is topped by ring upon ring of cedar, representing the prestige that a segmented chief's hat was woven to display. The Beaver proclaims Reid's mastery of the sculptured form. Haida conventions are evident in the straight forehead, the heavy eyebrows, the crisply defined, ovoid eye socket, the precisely carved ridge outlining the eye itself. Yet Reid's personal style is revealed as well. The depth and flare of the Beaver's nostrils and the sharp curve of the cheek down to the mouth are features that will later appear in Reid's silver, gold, and argillite pieces.

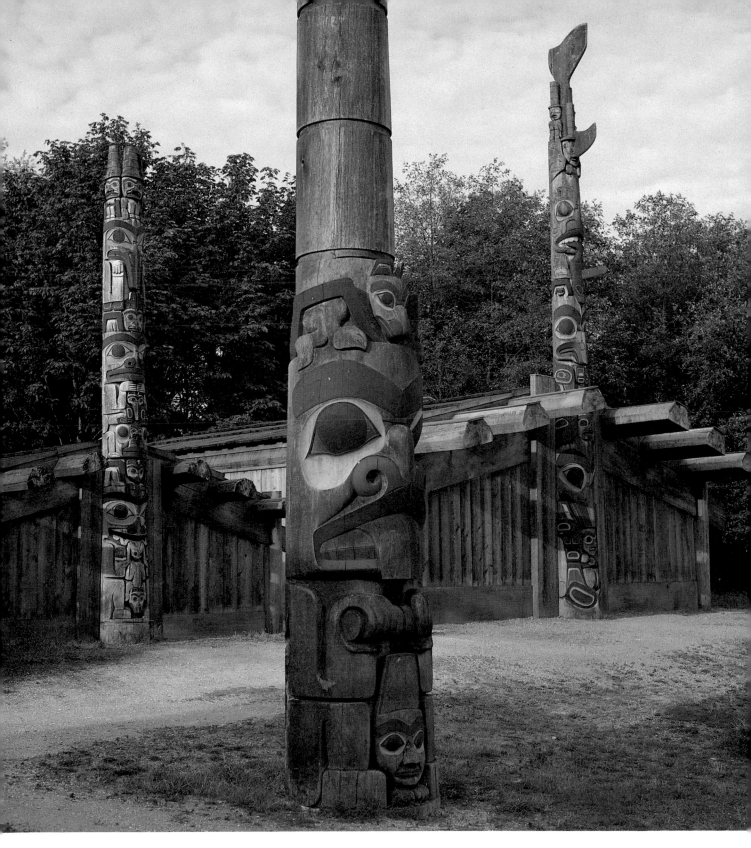

Plate I.  Haida houses and poles outside the Museum of Anthropology.

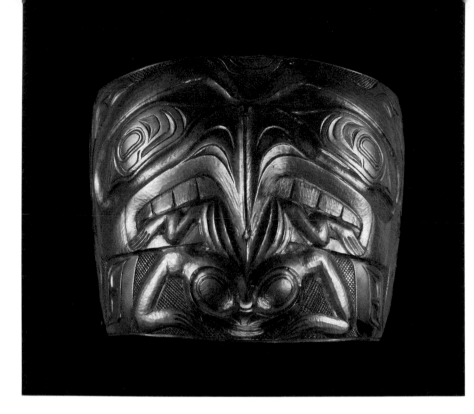

Plate II. Gold bracelet, Eagle and Frog, 1967 (6.3 cm. diameter x 5.4 cm.)

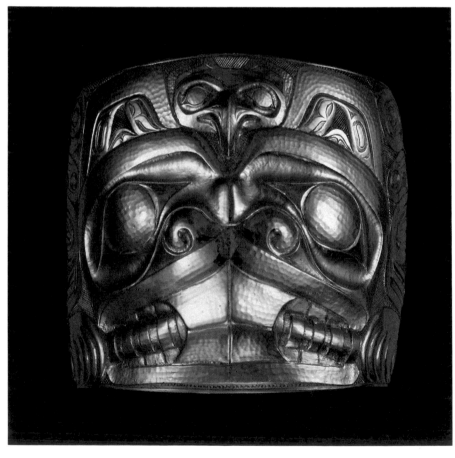

Plate III. Gold bracelet, Beaver and Eagle, 1970 (6.7 cm. diameter x 6.1 cm.)

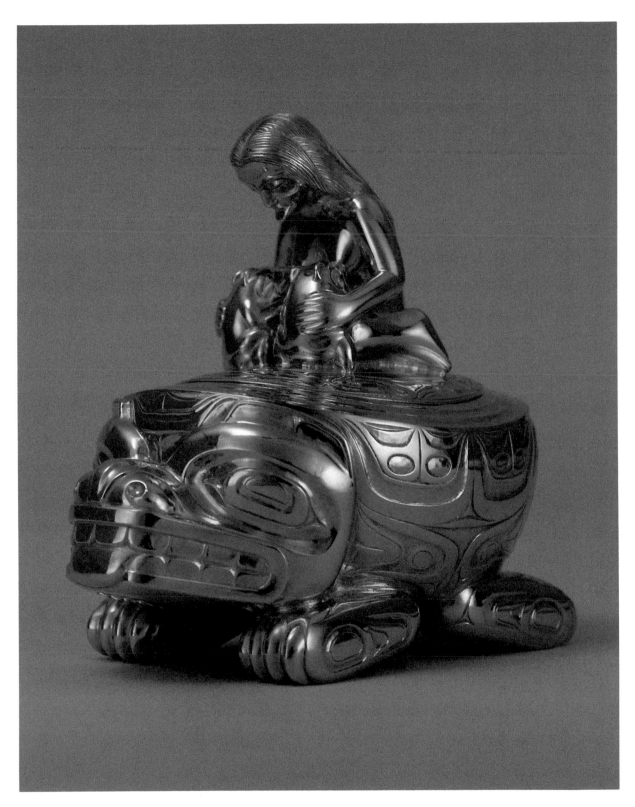

Plate IV.  Gold dish, Bear Mother, 1972 (7.3 x 7.0 x 5.2 cm.)

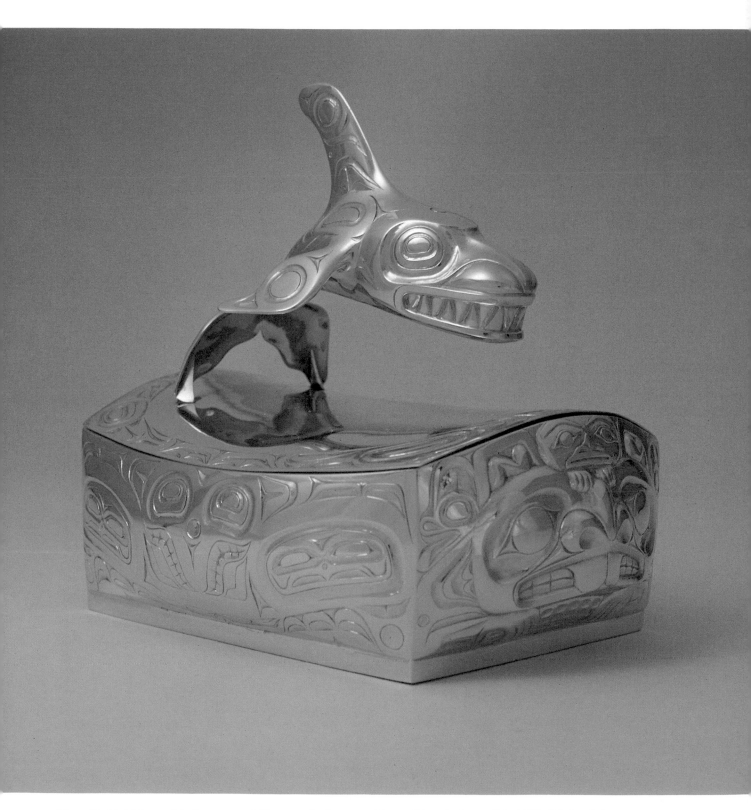

Plate V. Gold box with Beaver and Human design on sides, Killerwhale on lid, 1971 (10.0 x 9.4 x 8.2 cm.)

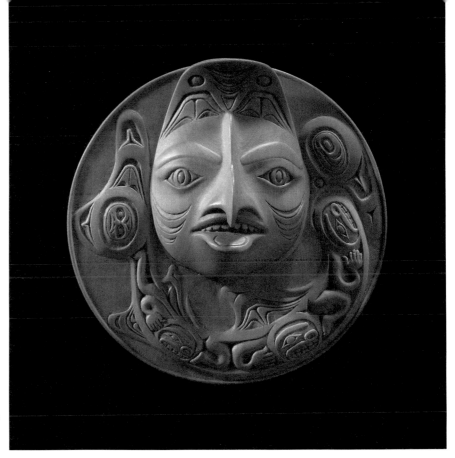

Plate VI.  Boxwood pendant,
Dogfish Woman, 1982
(8.0 cm. diameter)

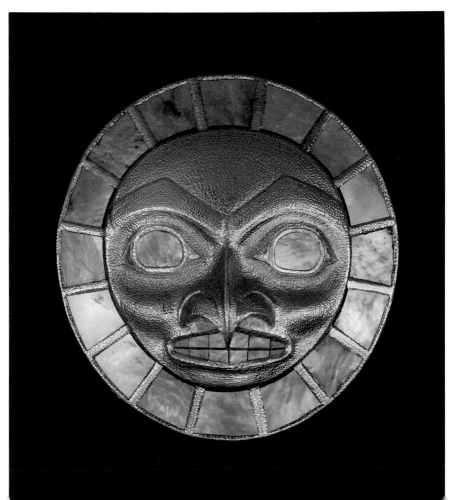

Plate VII.  Gold and abalone
brooch, Hawk,  1971
(5.8 x 5.4 cm.)

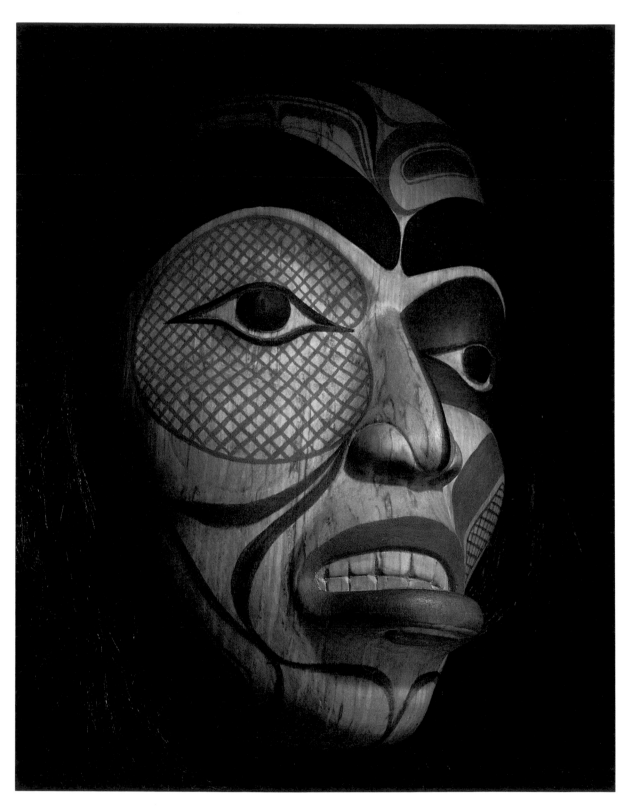

Plate VIII. Alder mask with hair, Woman, 1970  (23.2 x 16.8 cm.)

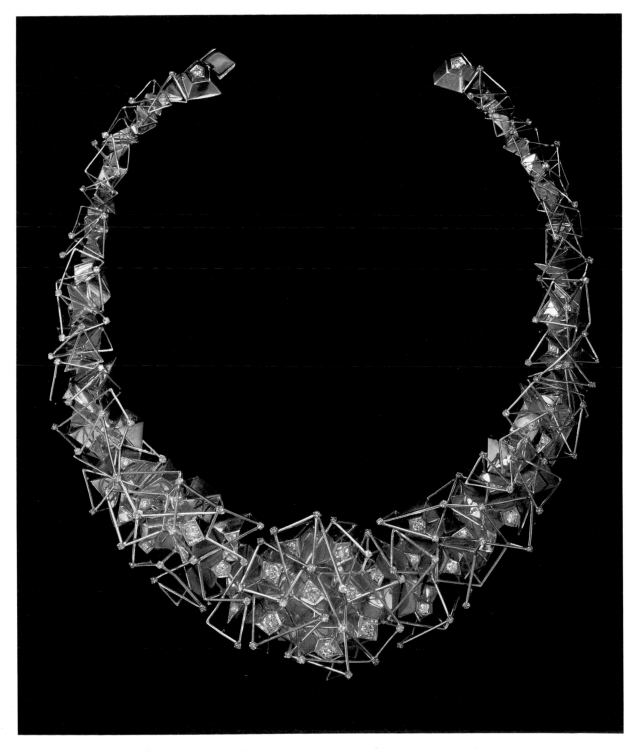

Plate IX.  Gold and diamond necklace with removable brooch at centre, 1969 (16.8 cm. diameter)

Plate X *(following page)*. Polychrome red cedar carving, Phyllidula: The Shape of Frogs to Come, 1985 (126.0 x 97.0 x 45.0 cm.)

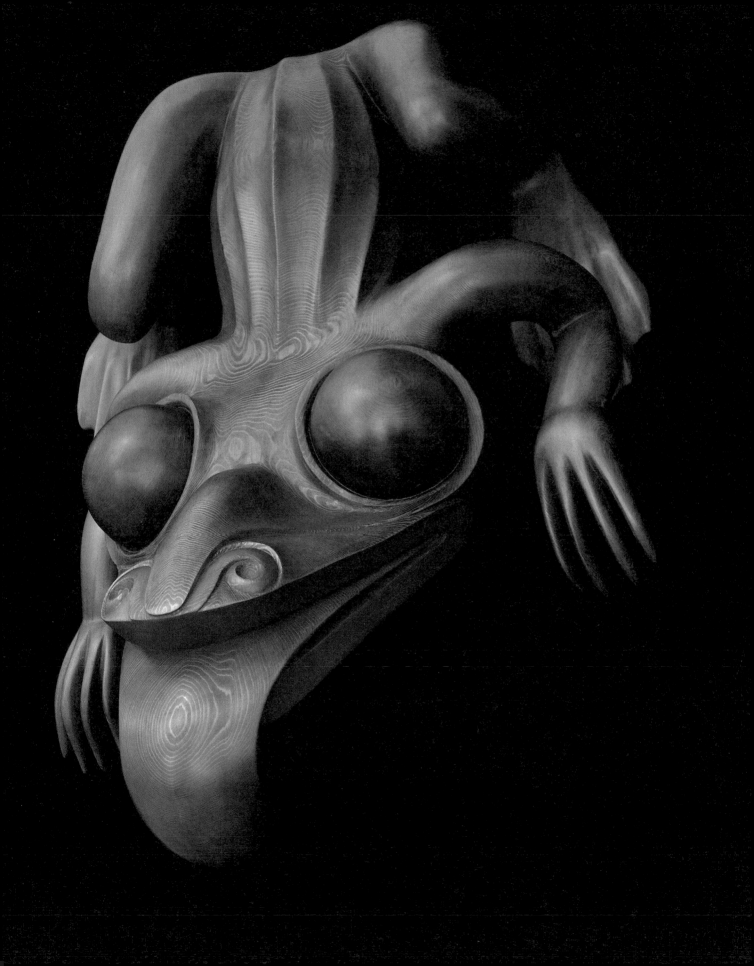

## Adaptations

Adaptations of traditional imagery using new techniques and new media predominate among Reid's miniature works. In 1957 he created a sterling brooch using the silver-overlay technique (fig. 43). The brooch depicts a Raven and Bear connected by beak and tongue to a small Frog, the entire composite image being formed within an elongated ovoid. The placing of the creatures and their organizational unity derive in essence from nineteenth-century argillite panel pipes. Reid achieves an elegant effect through the contrast between fine silver forms and dark background, though this early piece lacks his later accomplishment in two-dimensional design.

Panel pipes inspired another of Reid's early experimental pieces that features a configuration of Raven, Wolf, Whale, and Bear (c. 1960, fig. 44). Carved out of the dense, black, carbonaceous shale that is argillite or slate, Reid's miniature figures, inset into a sterling brooch, are given more depth and roundness than the silver-overlay technique allows. Reid worked the stone to greater effect, however, in his own full-sized version of the panel pipe (1969, fig. 27). In this twenty-seven-centimetre carving, ten intertwined creatures—the Sea Wolf with Killerwhales, the Raven and Frog, and the figures from the Bear Mother legend—are imbued with a sense of vigorous motion. The creatures move in opposing directions and at the same time achieve a balance in weight and composition. Working in classic Haida style, Reid reveals his artistry in the successful integration of sculptural form with the flat design that enhances faces, wings, and tails.

Moving from the argillite inspiration to new media and a monumental scale, Reid carved the 2.1-metre-square laminated cedar screen (1967, fig. 35) in the collections of the British Columbia Provincial Museum and designed the cast bronze frieze **Mythic Messengers** (1984, fig. 34) mounted at the entrance to Teleglobe Canada's

international centre in Burnaby, B.C. The figures are drawn from the same Haida stories that inspire many of Reid's works: the Bear Mother, the saga of Nanasimgit, the Dogfish woman, the Sea Wolf, the Eagle Prince, and the Raven and the Big Fisherman. All are themes which Reid and generations of artists before him have explored in wood and argillite. In the square format of the screen, however, the creatures interrelate in an unprecedented manner. One's eye is able to move through the design as it would along a continuous flowing formline. A similar effect is achieved in a lengthwise format on the bronze frieze, as individual figures clasp each other with hands and connect with long curved tongues in a symbol of communication. Reid has rendered the bodies with a degree of Western realism that makes his otherwise fluid argillite pipe appear almost stiff by comparison.

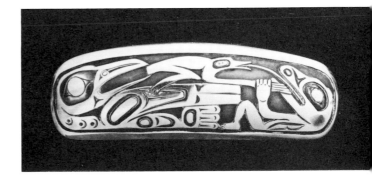

Figure 43. Sterling brooch, Raven, Bear, and Frog, c. 1957 (7.9 x 2.6 cm.)

Figure 44. Sterling and argillite brooch, Raven, Wolf, Whale, and Bear, c. 1960 (5.7 x 2.8 cm.)

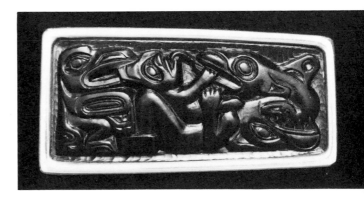

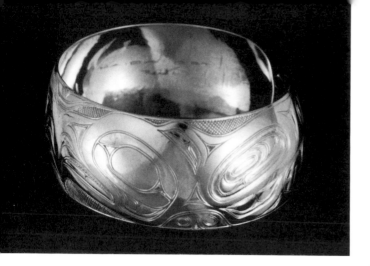

Figure 45. Gold bracelet, Eagle, c. 1959-60 (5.9 cm. diameter x 2.4 cm.)

It is in his bracelets that Reid's contribution to extending Haida tradition in flat and sculptural design is most strikingly apparent. In some of them, the iconography he interprets remains a copy or adaptation of older works. In his gold Eagle bracelet, for instance (c. 1959-60, fig. 45), a double line of engraving throughout the design is the most distinguishing aspect of a well-executed but ordinary split image. Other adaptations transform bracelets into works of sculpture. These pieces, by their own integrity, challenge the prevailing notion that jewellery's decorative function lessens its significance as "art." In fact, the small scale and wearability of the bracelets enhances the ways in which these works may be appreciated, particularly in the hands of their fortunate owners.

Much of the silver and gold jewellery produced by Northwest Coast artisans today relies on the glitter of the material to camouflage weaknesses in design. Bill Reid's most accomplished pieces, by contrast, show complete control of the medium. Four gold bracelets stand out in this regard: one incorporates fossil ivory in its depiction of Tschumos (c. 1964, fig. 46); another depicts a Bear with a small human figure (c. 1965, fig. 47); in the third, a Frog is held in the beak and teeth of a Haida Eagle (1967, fig. 48, Plate II), and an Eagle emerges from between

the ears of a Beaver in the fourth (1970, fig. 49, Plate III). Each bracelet illustrates the complementary relation between Reid's goldsmithing techniques and the overall design of the work. Technique itself becomes a form of artistic expression, bringing the magic of the metal to its full advantage. The result is reminiscent of the finest traditional animal-form bowls of the Northwest Coast: the creature and the object it embellishes become one and the same, creating a unity between function and aesthetics.

In true Haida style, the head of each creature dominates the bracelet, and the body is split and rearranged around the curved sides. These are powerful faces: Tschumos, who has the wide grin and flaring nostrils of a Grizzly Bear, but is actually the personification of a snag of wood emerging from the water; the Bear himself, showing his broad row of teeth and protruding tongue; the Eagle, who is no ordinary bird, has both a strongly curved beak and a human-like mouth, and the Beaver, his mouth and eyes angled upwards, clenches a chewing stick between his large incisor teeth. Reid used the repoussé technique to push the faces forward, raising them from the two-dimensional bracelet to achieve an even bolder sculptural form.

Reid does more than "follow the rules" in these works. The images are derived from Haida iconography, yet they become the artist's own. His attention to detail brings a depth and surface texture to the designs and is elaborately expressed in the finely engraved and inlaid ivory eyes of Tschumos. Even the hinged clasp by which the bracelet may be securely fastened shows Reid's intrigue with technique and the high standards he sets in his work. Detail and overall form combine to produce tremendous tension, as each monumental image is held in tight control by the small scale of the piece.

Reid's copies and adaptations of traditional Haida iconography have led him to express a dilemma concerning the recreation of old themes

40

in the present day. Using a word invented by Bill Holm, he calls himself an *artifaker,* meaning a creator of pastiches—pieces in nineteenth-century Haida style that are themselves originals. He acknowledges the possibilities that exist for formal innovation, but asks, *Is it, as Wilson Duff used to say, an art form in search of a reason for its own existence? A medium without a message? Is it all form and freedom and very little substance?* [26]

Reid's formalist approach to his art differs from the Haida artist Robert Davidson's emphasis on meaning. Davidson, born in 1946, is acknowl-

edged as the only other contemporary Haida master artist and probably the greatest innovator. He explores new principles of Haida design and space while actively creating a context for his art through ceremony. He says, *I can't create art or sing a song or dance a dance without meaning.... You can only go so far with academic knowledge. To go farther you need the experience.* [27] Davidson's source of imagery and substance derives from the artistic tradition he has internalized, and now flows outward as a true expression of his experience in contemporary ceremony.

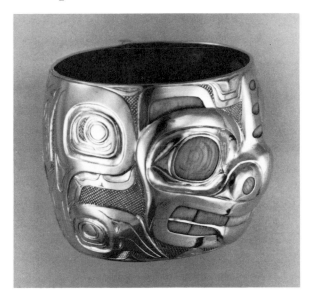

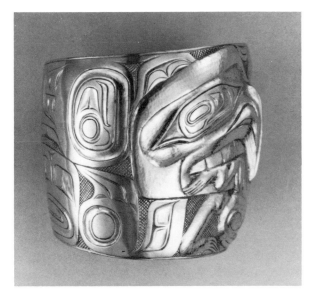

Figure 46. Gold and fossil ivory bracelet, Tschumos, c. 1964 (7.0 x 5.3 cm.)

Figure 48. Gold bracelet, Eagle and Frog, 1967 (6.3 cm. diameter x 5.4 cm.)

Figure 47. Gold bracelet, Bear and Human, c. 1965 (7.0 cm. diameter x 5.3 cm.)

Figure 49. Gold bracelet, Beaver and Eagle, 1970 (6.7 cm. diameter x 6.1 cm.)

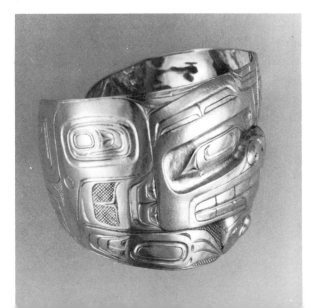

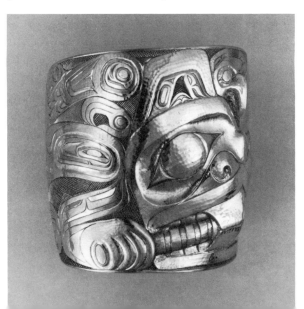

Perhaps, as Davidson suggests, Bill Reid could grow in his art by gaining more experience in the ceremonial dimension: *I would say that Bill's next task in order to complete the cycle of the art is to potlatch his people. To potlatch is to understand the culture. To potlatch is a direct experience with culture. … To potlatch and involve oneself is to bring meaning to the art on a deeper level. The art no longer becomes simply objects, but symbols of a surviving heritage handed down through the ages.*[28] To "go farther" in the art thus involves "going back" to the living Haida society. In choosing that direction himself, Robert Davidson is revealing his profound personal commitment to being Haida. Reid has also, in fact, taken several important steps in this direction, carving and raising a totem pole in his mother's village, initiating a canoe-carving project in the same community, and campaigning actively for the preservation of South Moresby Island, part of the ancestral lands of the Haida. But his roots extend with equal strength into his *WASP Canadian* heritage.

Reid's art synthesizes Haida symbols with his own source of experience as an individual occupying a marginal position between two societies. He comments, *Northwest Coast art can't exist without symbolism. I don't think you can take the basic structural forms, without the animal or mythical forms, and create a viable design. People have tried, but it doesn't happen, no matter how beautifully done.*[29] Here is a twentieth-century artist whose use of these symbols is not dependent on one definition of their meaning, nor is it dependent on ceremony. The objects he creates express the aesthetic structure of Haida art and at the same time reveal something of both old and new creative accomplishments. Reid has often said that aesthetics are a valid enough reason for the existence of his art today.

Figure 50. Pencil drawing, Nanasimgit and His Wife, 1982 (53.2 x 36.7 cm.)

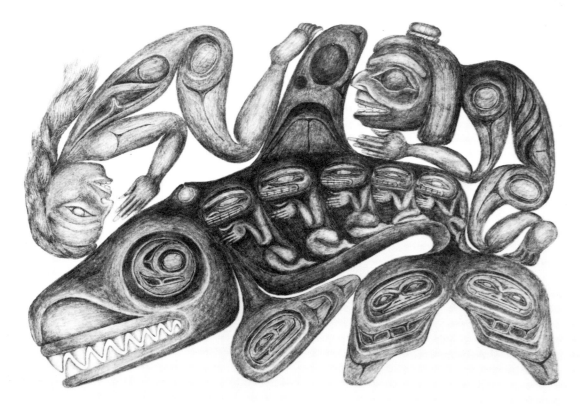

The development of Reid's art, from copying original ethnographic sources to exploring new boundaries, can be traced through successive interpretations of specific images and ideas. Several objects brought together for the Museum of Anthropology's exhibition, **Bill Reid: Beyond the Essential Form,** demonstrated one such continuity, based on their connection to the Raven tattoo design drawn by Wi'ha and published in 1905 by John Swanton (fig. 12). Reid's copy of the design in gold, described above, duplicates the formal structure of the original (c. 1954, fig. 10). The shape and placement of ovoids in the wings, feathers on the body, the shape of the head, the clawed feet, and the long tailfeathers are still evident, though altered, in works created over fifteen years later.

Using the repoussé technique highlighted with a hammered surface, Reid made a gold Raven brooch in 1971 that reinterprets the earlier Raven image (fig. 51). The brooch exhibits a similar head structure, thicker but almost identical legs and claws, and a curved, bulbous body, ending in extended tailfeathers. The wings are greatly exaggerated in their asymmetry. The left one begins with a circular joint and fans out into four rounded feathers, while a more complex ovoid joint in the larger wing flows downward into a u-form and narrows into two pointed feathers. Viewed separately, individual elements are greatly elaborated over their original source. Viewed as a whole, however, the brooch lacks a unifying rhythm as each element expands outward in its own direction.

Reid's dynamic Eagle brooch (1970, cover photo) radiates this rhythm in its portrayal of a bird poised in flight. The brooch is brilliant not only in substance but also in its exploration of traditional imagery. Derived from the same original Raven design, Reid's repoussé Eagle displays a finely hammered surface inlaid with jewel-like abalone shell on head, wings, and tail. Meticulous craftsmanship almost overwhelms the piece, except that Reid has cap-

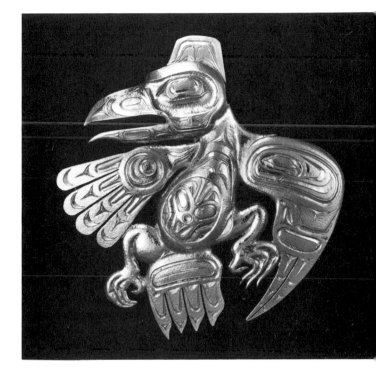

Figure 51. Gold brooch, Raven, 1971 (6.8 x 6.3 cm.)

tured the bird's energy in a masterful use of form. With its raised right wing and curved, feathered body, the Eagle takes on a rotational movement enhanced by the placing of ovoids and blue-green shell. The brooch's outline adds tension to the piece as it controls the outward force of the Eagle's wings.

A pendant of fossil ivory made in 1969 (fig. 30) presents the Eagle in a manner still related to past imagery but already hinting at Reid's forthcoming carving, **The Raven Discovering Mankind in a Clamshell** (1970, fig. 28). It is primarily in the finely carved feathers, the arched wings, and the configuration of two-dimensional elements that a continuity of image can be seen.

*Explorations*

Carved of boxwood, **Yehl** the Raven, his great head cocked, looms with powerful wings over a half-open clamshell containing the original Haidas, the first humans. The monumental image can be held in the hand: Reid's original rendition of the ancient Haida legend stands a mere seven centimetres high. Though he never intended the work to be any bigger, his massive yellow cedar version was completed in 1980 (fig. 3). The main difference in the large version, Reid once said, is that *it will be looking down at you instead of you looking down at it!*[30]

Both works take Haida sculpture and mythology into the twentieth century, beyond even Charles Edenshaw's rendering of the same theme in argillite (fig. 52). Edenshaw used the format of an engraved plate, and in the centre depicted a row of human faces emerging from a raised clamshell. While this work may have inspired Reid's interpretation, the boxwood piece is fully plastic and narrative in expression, and the effect is especially pronounced in the cedar version: Reid has freed the Raven and human figures from a static, totem-like portrayal, and so freed himself from some of the constraints of Haida sculptural tradition.

The power of Reid's Raven figure is dramatically emphasized by his size, for the trickster is many times bigger than the six humans cowering in his shadow. In true Haida style, the heads of all figures are disproportionately large, and the rimmed eyes are set in sharply defined orbs. The half-spread wings successfully integrate flat design with an almost naturalistic three-dimensional form. Perhaps most striking is the curved, feathered Raven's back, ending in a supernatural hawk/human face upside-down in the tail.

The humans appear as adults and infants simultaneously. Some are emerging from the clamshell/womb while others crawl back in, their stylized faces expressing curiosity and bewilderment at the world outside. Hands and feet, clinging to the rim of the shell, are surprising in their realism. In the boxwood carving, a female face peers from the clamshell beneath the Raven's wing. Her difference is marked by the labret in her lower lip. The figures in the newer carving, however, conform to Reid's narration of the Haida legend in which all the first humans are male.[31]

Figure 52. Argillite plate by Charles Edenshaw (c. 1839-1920), depicting the first humans in a clamshell (26.7 x 21.4 cm.)

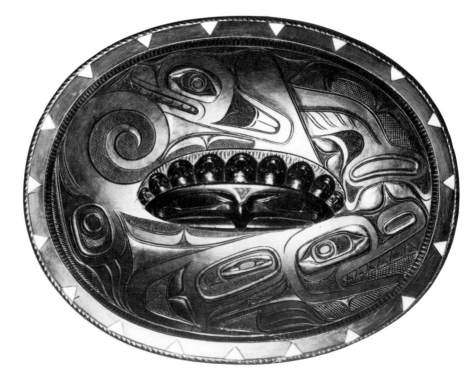

Reid considers boxwood the finest medium for carving. Its density allows a goldsmith's precision of detail. In boxwood, **The Raven Discovering Mankind in a Clamshell** exerts an impact far greater than its diminutive size. This impact is translated physically in the large version, thus sacrificing some of the mystery of the miniature. But the cedar sculpture displays its own strength, enhanced in form and finish by the artistry of Reid's skilful assistants.

Both works have evolved so far from copying old images that they may be considered entirely innovative. Yet by depicting the origin of mankind, Reid brings out ancient paradoxes in man's relation with nature and the supernatural. He also reveals a paradox in his own role as artist. Like the Raven whose image he interprets, Reid is a transformer of existing things. He retells stories belonging to a distant past, but does so with a modern perception of art. **The Raven Discovering Mankind in a Clamshell** is thus Haida, and it is universal: it follows the rules, and it breaks them.

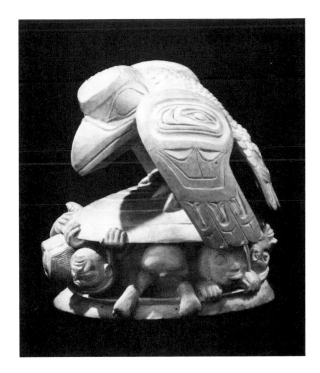

The Raven carvings and other Reid explorations can no longer be considered simply a revival of earlier aesthetic traditions. As innovative new developments, they take Northwest Coast art beyond the essential form—beyond, that is, the rules that have defined our expectations of both the two- and three-dimensional forms. Reid has said, *The formline is the basis of all the art. It is the essential element that sets the art from the north coast apart from any art in the world. If you don't conform to it you're doing something else.* He added, *When I felt impelled to do something radically different I went outside the Northwest Coast field altogether.*[32]

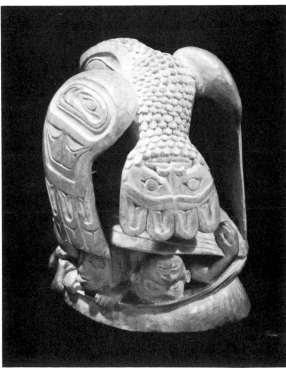

**Figure 53 a,b. Boxwood carving, The Raven Discovering Mankind in a Clamshell, 1970 (7.0 x 6.9 x 5.5 cm.)**

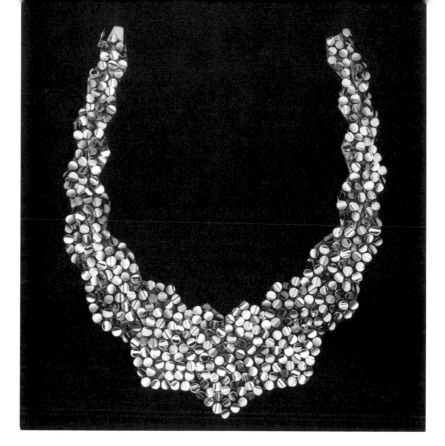

**Figure 54. Sterling and white gold necklace, 1979 (18.0 cm. diameter)**

Several of Reid's works are *non-Haida pieces, done just to prove I can do something else.* Perhaps best known among these works are two necklaces in contemporary, "international" style: one of gold and diamonds, discussed earlier (1969, fig. 25, Plate IX), and another of sterling and white gold (1972; second version made in 1979, fig. 54). Completed after his return from the Central School of Design in London, England, the necklaces are supreme examples of his goldsmithing skills and his love of complexity. Reid spent 750 hours creating the sterling and white-gold piece. It has a collar-like shape and a zigzag lower edge that comes to a deep point at front centre. The entire surface of the necklace is made up of hundreds of light-reflecting, concave facets of white gold. Each facet is soldered into a filed, hollow groove on the end of a piece of silver tubing. The tubes, in turn, are all drilled and soldered into a silver sheet backing. This necklace embodies the very qualities Reid strives for in his Haida works: exquisite, problem-solving craftsmanship, and a balance between courage and constraint in design.

Without leaving the Northwest Coast field, Reid carved an argillite totem pole in 1966 that still stands as one of his most dramatic works (fig. 31). Almost thirty-two centimetres high, the carving displays a sculptured depth more suggestive of Kwagiutl exuberance than Haida restraint. *It's a real can of worms,* says Reid. At the base, a Grizzly Bear and human engage in a seemingly violent exchange of tongues. A Sea Wolf rises from the Bear's head, his fin-like feet protruding through the Bear's ears, Killerwhales twisting under his own curled tail and front legs. A second small human rides the dorsal fin, his arms occupying the same space as the Sea Wolf's ears. Reid has carved the pole so deeply that the figures seem connected by their intertwined parts alone. Even the wings of the Eagle, who holds a Frog in his beak and perches on the Sea Wolf's snout, are almost separated from the body like an open cloak. The sculpture is a redefinition of argillite poles—ultimately Haida in its complex logic, expressly Reid in its vision.

Two gold bracelets stand out as well in their exploration of new possibilities. One, made in 1971, depicts elements from the Nanasimgit legend (fig. 55). The other was made three years later and depicts the Hawk Woman (1974). Reid used the repoussé technique to give a depth and sculptural elegance to the raised central face on each bracelet, and engraved the remaining area with a tightly bound band of two-dimensional design. The Hawk Woman, with her large ovoid eyes and broad nose and mouth, evokes the mystery of the transformative, half-human/half-bird image—her nose is a sharply defined beak, curving toward her mouth. The labret in the Hawk Woman's lower lip testifies to obvious high rank. In this work, Bill Reid has created a compelling piece through the sheer power of his technique and interpretation.

In the Nanasimgit piece, Reid transformed a dramatic tale into bracelet form. The woman depicted is the wife of Nanasimgit the hunter. She is kidnapped by the Killerwhales and taken to their undersea world. Through a series of encounters with birds and creatures of this super-natural realm, Nanasimgit rescues and returns her to his village on the beach. Her golden face, also with labret, gazes in an almost expressionless manner from the centre of the bracelet. On either side Reid has engraved one of her hands above a split Killerwhale. Within this engraved design Reid demonstrates his preference for handling the given space. His method contrasts with Robert Davidson's focus on transforming space, rather than simply filling it with the distorted or rearranged body parts of the creature represented. While Reid designs positive space to create a two-dimensional image, Davidson transforms the negative spaces between elements into positive forms. His creatures thus appear to emerge out of the total abstracted design.[33] Reid has achieved a similar effect in the Nanasimgit bracelet: from a myriad of engraved elements, the outline of Reid's Killerwhale reveals itself slowly to the eye.

Figure 55. Gold bracelet, Nanasimgit, 1971 (6.1 cm. diameter x 4.2 cm.)

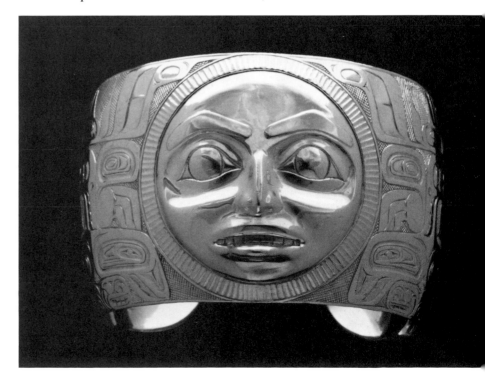

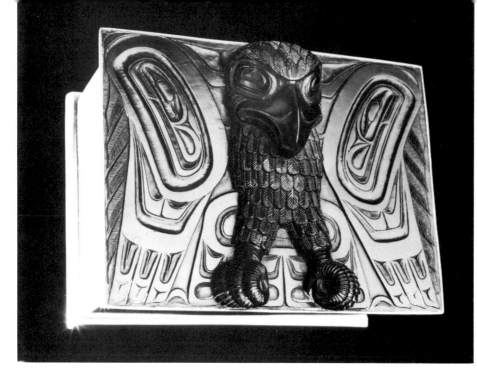

Figure 56. Sterling and argillite box, Eagle, 1971 (10.4 x 7.9 x 6.5 cm.)

In a series of gold and silver box sculptures, Reid explored the essential concept and form of northern Northwest Coast bent-corner chests and feast dishes. Each piece is a reinterpretation of the container format with lid. The lid becomes a platform for a three-dimensional figure or grouping. Reid's works have their precedents in masterpieces by Charles Edenshaw, including sculptured figures and objects perched on argillite chests, bowls, and platters. The media of gold and silver, and the techniques of assemblage, repoussé, and casting, allowed Reid to experiment with the forms and so achieve a balance between a traditional and a contemporary perspective. The resulting pieces bring our senses and emotions into play.

The first gold box of this series (1967, fig. 21) was commissioned for the Canada Pavilion at Expo 67. It is the least successful of the four boxes in its combination of disparate elements. Held together by the strength of soldering rather than unity of form, the box has a rectangular base representing a Bear, made up of a repoussé

head and angular two-dimensional designs. An Eagle, assembled from preformed segments, stands with outspread wings on the curved lid. Reid followed this piece with a sterling and slate box, also depicting an Eagle, but very different in format (1971, fig. 56). The sides of the box are plain and the lid is inset with argillite. In an energetic combination of two- and three-dimensional forms, the Eagle appears about to burst from the lid. The body is raised from the engraved wing designs: it is cloaked with exquisitely rendered feathers, and the powerful clawed feet are finely grooved. Although it is only partially sculptured, this Eagle projects a greater effect of strength than does its 1967 counterpart in gold.

The British Columbia Provincial Museum commissioned Reid to make a gold piece for their exhibition, **The Legacy**, in 1971. The show, which toured Canada, focused on the current state of Northwest Coast Indian art. It occasioned the museum's acquisition of the finest examples of contemporary work in wood, metal, argillite, basketry, and weaving. Reid's contribution was a gold Beaver and Human box with bulging sides and an undulating rim (fig. 57, Plate V). A three-dimensional Killerwhale, cast

by the lost-wax process, lunges from the top of the box, with only the tips of his tail flukes attached to the smoothly reflective lid.

The complete gold box is almost baroque in its ornamentation. All four sides are elaborated with deeply engraved designs. Raised from the front by the repoussé technique is the Beaver's face, his characteristic incisors and flared nostrils crisply defined. A small human peers from above, hands gripping the Beaver's forehead, and legs in the Beaver's ears. The body of the Beaver is fitted around the sides and back of the box, and his cross-hatched tail, complete with human face, appears at back centre. Reid followed the traditional practice in bent-corner box designs of incorporating subtle differences between the two long sides, so that they appear alike but are actually asymmetrical. He also included a ring of engraved elements around the edge of the lid, emphasizing the beautiful downward curve of the rim and leading the eye in a circular motion through the Killerwhale's form.

Reid calls his gold boxes *watershed pieces*, although he acknowledges some weaknesses in their design. The Beaver and Killerwhale box is striking in concept and rich in detail, but loses some tension in the overall composition of the sides and back. The faces on the sides, for example, draw attention away from any suggestion of the Beaver's crouching body. A similar problem occurs in the juxtaposition of sculptural form and two-dimensional elements on the body of the Killerwhale. The sculptural form is strong, the flat design superfluous. This effect is even more evident on the large scale of the bronze Aquarium whale, which was inspired by the gold box. Both works illustrate an aspect of Reid's style that he criticizes himself—his "horror vacuii" or "urge" to fill space with elements of flat design.

**Figure 57a,b. Gold box with Beaver and Human design on sides, Killerwhale on lid, 1971 (10.0 x 9.4 x 8.2 cm.)**

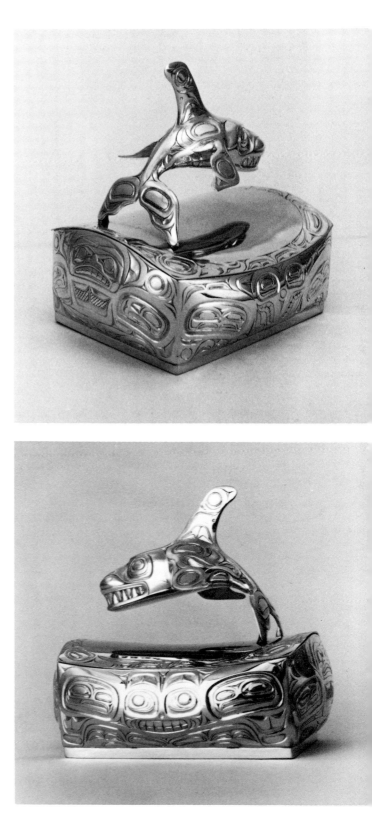

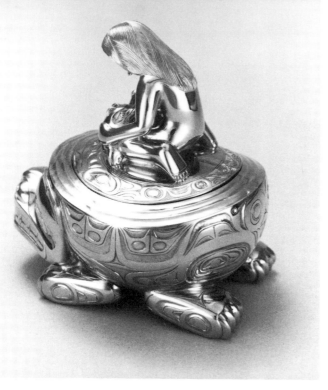

Figure 58. Gold dish, Bear Mother, 1972 (7.3 x 7.0 x 5.2 cm.)

The last comment may also be applied to Reid's gold Bear Mother Dish, fourth in the series of sculptured boxes and bowls (fig. 58, Plate IV). Made in 1972 while Reid was still living in Montreal, the piece was purchased by the National Museum of Man. It has been reproduced in countless photographs that give no hint of its diminutive size: only 7.3 centimetres in height and seven in length. Reid used his full range of jeweller's techniques to create this work of monumental impact. The rounded bowl is in the shape of a Bear, and on the lid kneels the human Bear Mother, nursing her twin cub children.

The Bear Mother legend is one of the greatest and most tragic of Haida tales. It tells the story of a beautiful, high-ranking girl who marries the nephew of the Bear Chief and gives birth to Bear-human twins. Her Bear husband is eventually forced to sacrifice himself to her human brothers in order to allow his wife to return to her village. Thus the powerful Bear clan of the Haida was established.

This legend has inspired striking Northwest Coast imagery, both traditionally and in more recent times. Bill Reid's dish was derived from an idea explored by Charles Edenshaw in an argillite compote (fig. 59). The compote is shaped like a Bear and displays the mother and cubs on the lid. The entire piece is mounted on a pedestal and is engraved with flowing formline designs. Reid's gold piece assumes a similar form, but expresses his own artistic vision. The Bear father is solid and massive in effect: his cast head projects forward, snout and tongue extended. The human mother is fluid and realistic in appearance. She holds her hands on the backs of her nursing cubs in a graceful and loving pose. Reid has engraved her hair in long, fine strands and shows a labret in her lower lip. One forgets that she also functions as a handle with which to raise the lid!

Like the gold Beaver and Killerwhale box, any weakness in the Bear Mother Dish lies in two-dimensional design, particularly in the series of u-forms and ovoids decorating empty spaces on the sides and the feet. The placing of these forms appears almost arbitrary: although they fit the space, they do not contribute to the controlled flow of energy that characterizes other elements of the bowl. Reid's greatest success lies in merging realism and Haida stylization in strong sculptural design. As seemingly opposite ways of portraying figures, the presence of both styles within one work of art emphasizes the difference between humans and supernatural animals at the same time that it symbolizes their legendary union.

Figure 59. Argillite compote by Charles Edenshaw (c. 1839-1920), Bear Mother (38.0 cm. high)

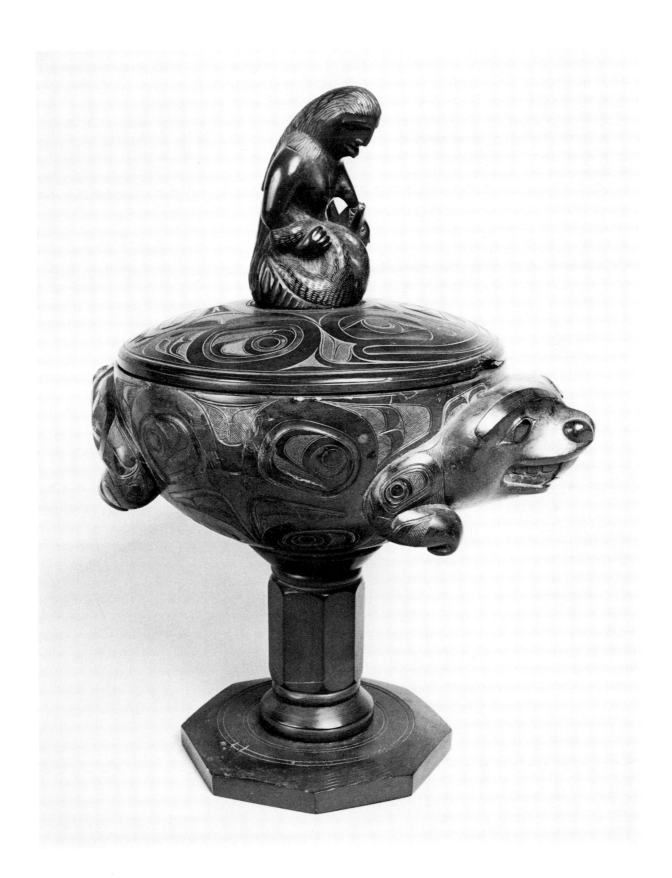

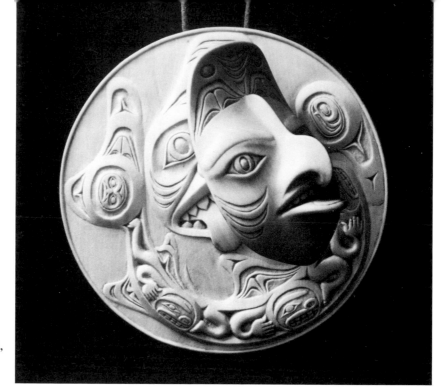

Figure 60. Boxwood pendant,
Dogfish Woman, 1982
(8.0 cm. diameter)

The theme of transformation, so integral to traditional Haida thought, is expressed most profoundly in Reid's superbly crafted boxwood pendant, the Dogfish Woman (1982, fig. 60, Plate VI). This supernatural shaman, whose powers derived from her attendant Dogfish spirit, is now only a half-remembered ghost of Haida legend. The myths that might give clues as to her origin and her relationship with the Dogfish are lost. But images have remained in old sculptures and painted designs to capture Reid's imagination. His pendant recreates and renews the Dogfish Woman's transformative magic.

Haida Dogfish designs are highly abstract but logical in their interpretation of the natural dogfish shark's anatomy. Reid has used the conventionalized features in his portrayal—domed forehead, gill slits, sharp teeth, and downturned mouth. The pendant is made up of a flat disc and an overhanging mask. Carved in low relief in the upper centre of the disc is a traditional Dogfish face: the Dogfish body is curved around the remaining area. On this miniature scale, Reid executes such fine details as three little human figures in a row, representing vertebrae.

Fitting perfectly over the Dogfish face is the separate, removable mask, hanging on a leather cord. The mask repeats some of the features of the shark, but also displays the humanlike qualities of the Dogfish Woman. She has leaf-shaped eyes, a partly open mouth with prominent labret, and a hawk-like nose/beak that curves to her mouth. As the mask is lifted from the Dogfish face, the instant of transformation is revealed.

The Dogfish Woman pendant is one of Reid's most unique explorations of ancient imagery. He has probed to the essence of the idea and emerged with a new expression that can be appreciated on many levels: as jewellery, as mythology, as craftsmanship, and as art. The sense of movement achieved in the pendant and such works as **The Raven and the First Men** points toward the directions his most recent work is taking. *Northwest Coast art reached the limits of its expressiveness in the conventions that developed over the centuries,* Reid says: *Now I've got enthusiastic about breaking the conventions.* His newest drawings, bronzes, and carvings incorporate the dimension of time through perspective and action.

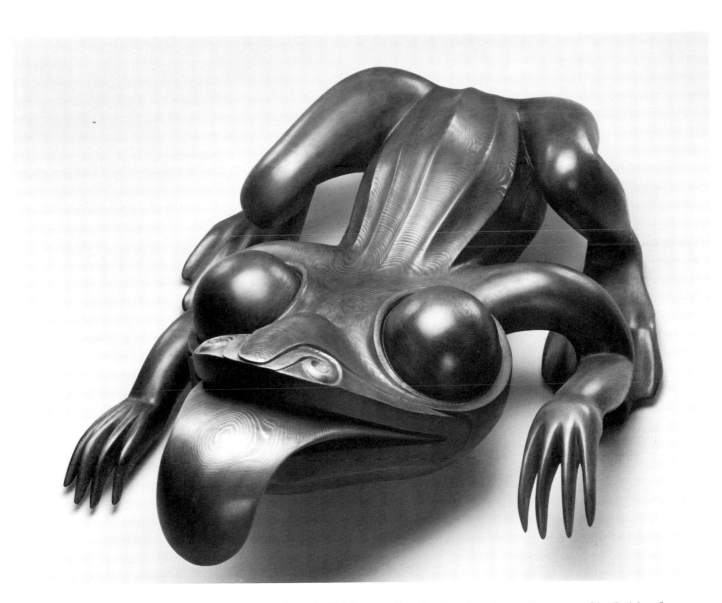

**Figure 61.** Polychrome red cedar carving, Phyllidula: The Shape of Frogs to Come, 1985 (126.0 x 97.0 x 45.0 cm.) *(see also Plate X)*

In 1985, Reid carved a Frog over a metre long, entitled **Phyllidula: The Shape of Frogs to Come**.

*Phyllidula is scrawny but amorous,*
*Thus have the gods awarded her,*
*That in pleasure she receives more than she can give;*
*If she does not count this blessed*
*Let her change her religion.*

Ezra Pound, 1916

Carving for the sheer pleasure of it, Reid refers to *the old carver's mystique* of peeling away the layers of wood and finding what is concealed inside. A scrawny but humorous green Frog resulted, sitting on all fours and looking up through curiously blank, bulbous eyes. It has a wide red mouth with a protruding tongue, and curled nostrils like the fronds of a fern. Full of life, the Frog skips over the "rules" of Haida art into a synthesis with European sculpture. There are echoes of its form in older carvings: one now famous Frog appears to crawl out from under the Killerwhale's tail on a pole at Skungwa'ai

(Ninstints); another emerges from the Bear's mouth on Reid's copy of a mortuary house frontal pole (fig. 62). The gold repoussé Frog Reid made in 1971 (fig. 23) is also an ancestor to Phyllidula. The ridges on its back and its flexed legs with long, toed feet show a continuity of image from past to present.

Frog images were sometimes used in traditional Northwest Coast art as puns, or mental tricks. Is this Frog laughing at a joke it is playing on us? People have responded to the piece with delight and dismay, proclaiming it both the essence and the antithesis of Haida art. Reid's background in Haida design has inevitably influenced the Frog's form. He comments, however, that Phyllidula was a spontaneous expression, and cannot therefore look like the work of a nineteenth-century artist.

Figure 62a. Haida Frog on pole at Skungwa'ai (Ninstints), 1901.

Figure 62b. Mortuary house frontal pole, 1959.

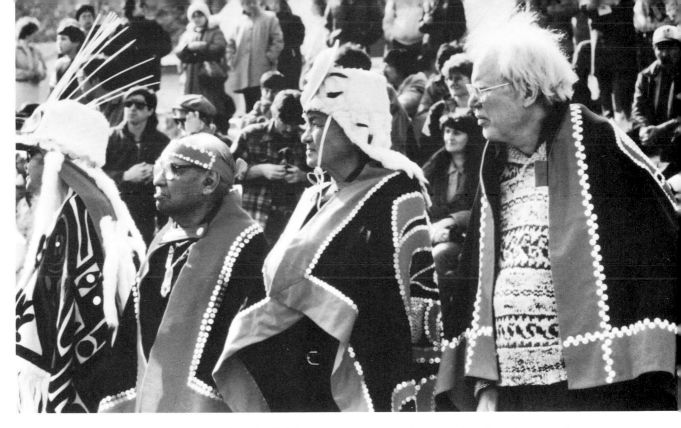

Figure 63. Bill Reid (far right) stands with Haida hereditary chiefs (left to right) Alex Jones, Watson Price, and Ernie Wilson at the ceremonial launching of his fifty-foot canoe at Skidegate, 12 April 1986.

Reid's artistic growth has proceeded through a development of ideas and images, from initial direct copies to explorations of the boundary between Haida and non-Haida art. Reactions to his most recent works still reveal an uncertainty in some critics' minds, and perhaps even in Bill Reid himself, about the push-and-pull tension between copyism and innovation. By adding a dynamic quality to the contained and static creatures of Haida poles, has Bill Reid broken the boundaries of the art or extended them? While still building upon Haida imagery and form, is he creating a new tradition?

Today, Reid returns regularly to Skidegate to work with other carvers on such projects as the construction of a traditional ocean-going Haida canoe. At the same time, he is attempting new artistic experiments that break away from the essential form he has mastered. He is pleased with the generally positive responses his work receives, particularly the large sculptures set in public spaces. Killerwhales, Frogs, and Ravens are now familiar images in the public's mind. Northwest Coast art seems to be the popular art of the day, Reid says, providing a means of communication between native and non-native societies.

How is it that contemporary expressions of Haida themes can speak so eloquently to the non-native world? The riddle is answered in the ambiguity of Reid's best work: the stronger the roots of an art, the more universal its appeal is likely to be. With a foot in each culture, Reid has looked in both directions at once, exploring not only the constraints but also the freedom of transforming traditions. His ongoing dialogue with the *well-made object* will continue to bridge the contradictions of time and place. Whether he is accompanied by the creatures of legends or new imagery of his own, Bill Reid is contributing to a new definition of Haida art.

Figure 64.  Bill Reid working on the clay model for
a forthcoming sculpture, Mythic Canoe, 1986.

# Notes

1. Claude Lévi-Strauss, in **Bill Reid—A Retrospective Exhibition** (6 November—8 December 1974, Vancouver Art Gallery).

2. Bill Reid, *Curriculum Vitae*, in ibid. This is also the primary source for the biographical information and related quotes presented in this section.

3. Bill Holm, in *Tributes to the Artist*, in ibid.

4. Bill Reid, *Curriculum Vitae*.

5. Wilson Duff, *Bill Reid: An Act of Vision and an Act of Intuition*, in ibid.

6. Bill Reid, in **Northwest Coast Indian Artists in Dialogue** (lecture series at UBC Museum of Anthropology coordinated by K. Duffek, 27 March 1984).

7. **Occasional Papers**, No. 5 (Victoria: British Columbia Provincial Museum, 1944).

8. Bruce Inverarity, **Art of the Northwest Coast Indians** (Berkeley: University of California Press, 1950).

Marius Barbeau, *Haida Myths Illustrated in Argillite Carvings* (**National Museums of Canada, Bulletin No. 127**, Anthropological Series, No. 32, 1953) and *Haida Carvers in Argillite* (**National Museums of Canada, Bulletin No. 139**, Anthropological Series, No. 38, 1957).

John Swanton, *Contributions to the Ethnology of the Haida* (**Memoirs of the American Museum of Natural History**, New York, Vol. 5, Pt. 1, 1905 [see especially page 142 and plate XXI]).

9. Franz Boas, **Primitive Art** (New York: Dover Publications, 1955; originally published by the Instituttet Sammenlignende Kulturforskning, 8, Oslo and London, 1927). Reid was referring to figure 287b in the 1955 edition.

10. Bill Reid, *The Box Painting by the "Master of the Black Field,"* in **The World is as Sharp as a Knife: An Anthology in Honour of Wilson Duff**, Donald N. Abbott, ed. (Victoria: British Columbia Provincial Museum, 1981), 301. The box is in the collections of the American Museum of Natural History, New York; catalogue number 19/1233.

11. Bill Reid, in **Northwest Coast Indian Artists in Dialogue.**

12. Bill Reid, *The Art—An Appreciation*, in **Arts of the Raven** (15 June—24 September 1967, Vancouver Art Gallery).

13. Bill Reid and Bill Holm, **Indian Art of the Northwest Coast—A Dialogue on Craftsmanship and Aesthetics** (Houston: Institute for the Arts, Rice University, 1975), 86.

14. Ibid., 36.

15. Bill Reid, in **Bill Koochin** (19 March—27 April 1980, Burnaby Art Gallery), 2.

16. Peter Macnair, Alan Hoover, and Kevin Neary, **The Legacy** (Victoria: British Columbia Provincial Museum, 1980), 69.

17. Bill Reid, in **Indian Art of the Northwest Coast—A Dialogue on Craftsmanship and Aesthetics**, 35.

18. Bill Reid, in **Bill Koochin**, 2.

19. Doris Shadbolt, *Foreword*, in **Arts of the Raven**.

20. Bill Reid and Adelaide de Menil, **Out of the Silence** (Amon Carter Museum of Western Art, New York: Harper and Row, 1971).

21. Bill Reid, in **Northwest Coast Indian Artists in Dialogue**.

22. Ibid.

23. Bill Reid, *The Legacy Review Reviewed*, in **Vanguard** (Vancouver Art Gallery, Oct./Nov. 1982), 35.

24. Catalogue number HN 1408. The piece was collected by Paul Kane on his journey of 1846-48 and was exhibited in **Arts of the Raven** (#236) in 1967. Length: 11.4 cm.

25. Bill Reid, in **Indian Art of the Northwest Coast—A Dialogue on Craftsmanship and Aesthetics**, 134.

26. Bill Reid, *A New Northwest Coast Art: A Dream of the Past or a New Awakening?* (paper presented at **Issues and Images, New Dimensions in Native American Art History**: conference, Arizona State University, 22-24 April 1981), 11.

27. Personal interview with Robert Davidson, 3 January 1986.

28. Personal interviews with Robert Davidson, April 1986.

29. Bill Reid, in **Indian Art of the Northwest Coast—A Dialogue on Craftsmanship and Aesthetics**, 73.

30. Bill Reid, in **Introduction to Northwest Coast Indian Art** (lecture series at UBC Museum of Anthropology, 6 February 1979).

31. Bill Reid, **The Haida Legend of the Raven and the First Humans** (UBC Museum of Anthropology Museum Note No. 8, 1980).

32. Bill Reid, in **Legacy Dialogue** (lecture at UBC Museum of Anthropology, 24 February 1982).

33. See Marjorie Halpin, **Cycles—The Graphic Art of Robert Davidson, Haida** (UBC Museum of Anthropology Museum Note No. 7, 1979) for a detailed discussion of Davidson's two-dimensional designs.

# Photographic Credits

American Museum of Natural History: Figures 7 and 16, E. Dossetter; 13 (neg. no. 2A12668, courtesy the Department Library Services).

British Columbia Provincial Museum: Figure 35; 62a, C.F. Newcombe.

Alfred Carmichael: Figure 6.

Bill McLemore: Figure 55.

Bill Reid Collection: Figure 5.

Sheldon Jackson Museum: Figure 59.

Ulli Steltzer: Figures 32, 33, 39.

Ulli Steltzer and Douglas & McIntyre: Figures 17, 28.

UBC Museum of Anthropology: Figure 63, J.L. Gijssen; cover photograph, endpapers, and all other figures and plates not listed, W. McLennan.

Vancouver Art Gallery: Figure 61, Jim Jardine.

# Artifact Ownership Credits

American Museum of Natural History: Figure 13 (#19/1233).

British Columbia Provincial Museum: Figures 35 (#16639), 57 and Plate V (#13902).

National Museum of Man: Figure 58 and Plate IV.

Private collections of Susan Jane Davidson, Jean Fahrni, Stanley P. Gregory, Audrey Hawthorn, Sherry Keith-King, Michael and Sonja Koerner, J. Ron Longstaffe, M. Lois Milsom, Bill and Martine Reid, and anonymous lenders: Figures 1, 8, 10, 14, 20, 21, 22, 24, 25, 26, 27, 29, 30, 31, 36, 41, 42, 43, 44, 45, 46, 47, 48, 49, 50, 51, 54, 55, 56, 60, Plates II, III, VI, VII, IX, cover photograph, and endpapers.

Sheldon Jackson Museum: Figure 59.

Teleglobe Canada: Figure 34.

UBC Museum of Anthropology: Figures 2 (#A50045), 3 and 4 (#Nb1.481), 11 (#A1499), 15 (#719/1), 18 (#A8094), 19 (#A1500), 23 (#A9349), 28 (#Nb1.488), 52 (#A7049), 53 (#Nb1.488), 62b (#A50033), Plates I, VIII (#A2617).

Vancouver Art Gallery: Figure 61 and Plate X (#VAG 86.16).

Vancouver Public Aquarium: Figure 37.